: 7 OC

2 0 FEB 2

Pavel Büchler

Ghost Stories

stray thoughts on photography and film

Proboscis

London

First published in 1999 by Proboscis in association with Errant Bodies
PO Box 14649, London, EC2A 3RD

Edited by Giles Lane & Brandon LaBelle
Designed by Louise Sandhaus
Printed & Bound in England by Geoff Neal Litho, Middlesex
in an edition of 2000

Distributed by:
Art Books International Ltd.
1 Stewarts Court, 220
Stewarts Road, London SW8 4UD

DAP/Distributed Art Press
155 6th Avenue, 2nd Floor
New York, NY 10013-1507
USA

British Library Cataloguing-in-Publication data:
A CIP record for this book is available from the British Library

Proboscis and the Author wish to thank the Arts Council of England
Visual Arts department whose generous financial support
has made this publication possible.

ISBN: 1 901540 07 3

For the lost souls of modernity

Table of Contents

11/5/98 Manchester

"Hey, I know this guy!" Three men burst through the open door into my studio, brandishing, in turn, a plastic shopping bag, large video camera and a fluffy microphone.

"Do I know you?"

"Martin Parr!"

"Oh yeah... and what's this?"

"German TV crew. I always have a TV crew with me wherever I go. The only way to travel. They pay for the drinks." He rattles the contents of his Tesco bag, "My slides. I'm supposed to be doing a lecture in a minute somewhere 'round here."

He speaks at the top of his voice, almost shouts, gesticulates, his facial muscles pushing the corners of his mouth up in a sturdy grin – like a small-time politician on a bad weather Sunday morning walkabout, addressing the world for the audience of one.

Martin Parr is an amazing photographer. His pictures intrude on the trivia of domestic and social existence, but not without a touch of empathy, with a loud 'gotcha' written all over them. I like them almost against my better convictions, I can't resist them, not for what they depict but for what they document: a certain action of photography, its ability to disrupt, even disturb, the privacy of looking.

The editor in the German television studio will have a torturous experience viewing the miles of video tape, fast-forwarding, no doubt, to escape the tedium of real-time action and the campaigning volume of Parr's monologue. But in those random stoppages that will finally hold together the continuity of the dramatic action, and that the viewer will never be privileged to see, he may be rewarded by images that have the fascination of Parr's shot-from-the-hip photographs. And as more and more tape will gather on the floor – or, more precisely, as the recorded footage will vanish into some digital limbo – it may cross his

mind that photography is an art of editing. Only when selected and ordered in some manner, do photographs become photography in any meaningful way.

Every selection requires criteria. But what kind of a criterion is the banality of an accident? And what is the interest of the erratic? Parr does seem to be taking pictures that are potential rejects (he also collects postcards of the sort that makes you wonder why anyone should have bothered to photograph those things in the first place). And then, I imagine, he arrives at a photography by discarding all the 'interesting' shots, all the 'good' ones, and anything that he would not put in his collection of photographic trash.

Following this logic, the true Martin Parr documentary will be the one condemned to the editor's waste bin.

The selection of the texts for this book was a little like the process described in my diary entry. Almost half of the pieces are fragments, first drafts or sketches and all but a few were written on the spur of the moment, some in response to photographs and films, articulating impatient stray thoughts rather than methodical thinking. I have picked them out from an assortment of occasional writing, guided only by a persistent idea that there is something ostensibly strange – enigmatic rather then merely odd – about photography and its various manifestations. Except for that conviction, which I will hold until I find a photograph to dispel it, many of my views recorded in the earlier texts have changed – as has, of course, the debate in which they wanted to take part. Some of those temporary positions may have by now become quite untenable, so much so that it would be futile to try and update them. I can only hope that presenting them as they are will reflect something of the changing critical climate in which these texts came, one by one, into being.

This may also account for some of the terminological inconsistency and confusion. Where this is evidence of my unsystematic and unfocused reading habits, I should apologise not only to the present reader, but also, *in absentia*, to those whose work I read and failed to learn from – Roland Barthes, Susan Sontag, Hollis Frampton, to name a few.

But I make no excuse if, cumulatively, these texts appear to collide in countless contradictions and self-contradictions. They must defend themselves – not because such collisions cannot be spirited away, but because they are, in a sense, the theme.

That said, I owe my thanks to many friends who supported my attempts to write over the last ten years: especially Mark Lumley, former co-director of the Cambridge Darkroom, Peter Turner and David Brittain, editors of CREATIVE CAMERA, Gloria Chalmers, the editor of PORTFOLIO, the curators Andrew Nairne and Charles Esche, and Alice Angus who assisted me for some of the time. I am grateful to the artists who granted me the permission to reproduce their work in this publication, to the editors Giles Lane and Brandon LaBelle for having faith in me, to Nikos Papastergiadis for his criticism, to my wife Alexandra for her patience (and, while I am at it, on this occasion to Martin Parr).

On Reflection "And he looked away from the photograph for a little while. When he looked at it again he noticed his mother's hand, which dropped from the arm of the chair in the foreground, near enough to kiss." – Franz Kafka, AMERIKA A friend told me a beautiful story. Her grandfather was a photographer in Tromsø, northern Norway. He was an old-fashioned type of a man distrustful of novelty, who worked with a vintage wooden and brass Linhoff camera and glass plates and never in his life touched "this thing called film." During the war in the 1940s, when glass was in short supply, his daughter recycled some of the old photographic negatives to repair broken bedroom windows. But even after she had stripped off the gelatine emulsion with alcohol, faint traces of the images still remained on the surface of the plates. They were invisible in daylight, but in a

certain light during the polar night, the faces of people photographed years before appeared like ghostly reflections etched into the small window panes.

The 'window', like the 'mirror', is not just an established emblem for photography's distribution of light in its commanding relationship to nature and its pursuit of an ordered vision of the world, nor is it only a metaphor for the prospects opened to the sight by the photographic image. It is also the apposite subject of two of the most important pictures in the history of photographs. In 1826, after an eight-hour exposure with the camera obscura, Joseph Nicéphore Niépce fixed a photographic image of a view from the attic window at his country house near Chalon-sur-Saône and for the first time sealed the ephemeral action of light in a permanent present. A decade

later, one sunny afternoon in August 1835, William Henry Fox Talbot took a picture of a latticed window from inside Lacock Abbey, producing the first photographic negative from which identical positive prints could multiply in a potentially infinite number of copies. Both of these images are barely distinct, lacking in detail and resolution (no matter how proudly Talbot reported that in the tiny window, "when first made, the squares of glass about 200 in numbers could be counted, with help of a lens"). They are the prototypes, mere tenuous suggestions of images, half-whispered propositions of things to come, but in all their imperfection they also retain an irreversible presence which marks, so to say, points of no return.

If the method of "automatic reproduction of nature" discovered by Niépce and later developed by

Daguerre was "perhaps the most extraordinary triumph of modern science," as it appeared to Edgar Allan Poe, and "upset," in the words of another contemporary comment, "all scientific theories of light and optics," then the postage stamp-sized negative made by Talbot was a revolutionary breakthrough for an industry of production which, by the end of the century and the time of Alvin Langdon Coburn, made a photograph "as common as a box of matches" and almost as ordinary. By that time, the art of photography no longer symbolised the old aspirations of learning and science to subject nature to the order of human invention (or "to meditate upon celestial blessings," as a seventeenth century alchemist wrote about the task of chemistry), but a new popular desire to gather, hold and keep impressions generated by human presence in the

world, to trade and distribute them, and give them a purpose in the culture of modern living. After Niépce's 'heliograph' and Talbot's 'callotype', the beautiful picture, there came 'Kodak', a name inspired by no loftier an ideal than that it "could be pronounced anywhere in the world," bringing photography from the (Greek) heavens permanently down to earth.

The technological developments which have brought about a rapid and global proliferation of photography and a complete naturalisation of the photographic image within material culture have been driven from early on in photographic history by the conflicting impulses of anxiety and faith. The delirium of modern photographic production and consumption feeding on visual lust and material greed involves the conviction that in the image we can possess something that lies beyond

the reach of sight; and the belief that there is more to see and more to have, more to wonder at and more to see more clearly, demands assurances that the photograph has nothing to hide. We expect the perfect photograph to be both different from what it shows so that it may add to the phenomenal repository of the world, and wholly indifferent to its own condition so that it may act as neutral intermediary between subjective vision and an objective view. The drive towards photographic perfection strives for pictures which are at once ever more life-like and ever more unlike anything else in life; images which create and recreate the world as it appears to our eyes, in colour and perspectival depth, but also as it is beyond the threshold of perception, in greater detail, at a greater speed, from a greater distance, in a word, enhanced. The desire for the

perfect image, as transparent as it is evident, is a desire to see both more and less of photography.

This paradox is largely codified in the photographic culture by the process of technological 'democratisation' of photography. The tendency of modern technology to reconcile the demands for greater individual control with automation, standardisation and access discriminates in the social realm between the 'photographer', a professional supplier of images for public consumption (for brevity's sake), and the casual practising consumer, the anonymous amateur, or perhaps better, the private 'lay photographer'.[1] Where the former is licensed, by the conventions of language as much as by the institutions of photography, to engage in the active pursuits of 'making' or 'capturing' pictures, there the latter is invariably restricted to the passive

mode of 'taking', in the sense of 'receiving'. And where the photographer is both the expert witness and the interrogator of photography, while also being a high priest of the singular, self-conscious image, as it were, there the lay photographer is cast as the true agent of photography from whose camera images seem to flow in a continuous stream. Increasingly, the lay photographer is being armed with 'professional equipment', prompted to take pictures of 'professional quality', but this is only to encourage the exercise of consumer choice as the growing sophistication of the apparatus feeds the appetite for 'more' by allowing us to do, in relative terms, 'less'. Ever since George Eastman's notorious confidence trick, "you press the button, we do the rest," the relationship between picture taking and photographs is one of diminishing engagement. It is no long-

er only processing and printing, the chemical and mechanical conversion of the image into discrete objects, which is left to professionals and the photographic industry, it is by now almost every technical aspect of the image itself that is built into the automatic operations of the equipment, such as focusing, exposure or timing.[2] The 'intelligence' of the technology imposes with an ever increasing determination the conventions of perfect reproduction onto our photographic thinking, so much so that, for example, to produce a blurred photograph has come to be seen as the exclusive right of the professional, even a sure sign of the professional mandate, whereas the same blurred image taken by the lay photographer implies a 'human error'. The growing automation of photography means a growing autonomy for the photograph. In turn, photography

en masse, for the everyday purposes of the lay photographer/ consumer, maintains the sense of the 'automatic' and 'spontaneous' which, for Daguerre, was once the basic pre-condition for allowing "nature to reproduce herself."

Mass or 'popular' photography is not just a nominal technical category. It is a technologically imposed perceptual (even existential) mode of private visual indulgence affecting all our encounters with photographs. The gratification that the constantly watching eye gets from photographs is informed by two distinctly different kinds of experience: the thrill of looking and the pleasure of seeing. The first comes from the transformation of raw visual information into the aesthetic and symbolic content of the picture; the second is generated by a recognition of a residue of life in it. Both are the consequences of the operations of

recording and processing technology, but the perception of the difference between them seems to follow some pre-photographic dialectic of images to the point at which the image finally merges with experience. Looking at a photograph, associated in our experience with the familiar use of the camera, the view through its viewfinder, uncovers photography as a frame (and the unseen conceptual framework) for the self-becoming of the image. In looking, the metaphor of the 'window' seeks its justification. Seeing, on the other hand, is in this sense an act of recognition of those 'reflective' properties of photography which seem to justify its reputation as a 'mirror'. To reflect is both to show and to hide. Seeing what a photograph shows, what it reflects in its surface, may be as simple as looking, but to engage with what it hides requires the conceptual

integration of the existence of the image in the self-conscious experience of being. It can perhaps be described as a 'reprocessing', a kind of conceptual reversal through which the illusion of the image is confirmed as it is being unmasked as doubly fraudulent. There is something quite literally strange and extraordinary in the nature of photographs which seems to come to the surface before us in those moments when we realise that the 'image' is only partly 'visual': that it is truly an 'impression' – neither just an 'image', nor quite an autonomous object, neither 'nature herself', nor a mechanical fabrication – wholly material and coexistent with our reality and yet also of another world.

Through the 'familiarity' with the automatic operations of the photographic hardware our experience of photography is gradually 'drying up'.[3]

It makes us forget that photography
has become the technology for altering
the habitual ways of seeing through a
fusion of the agencies of alchemy and
optics: a transmutation of precious
metals meeting a geometry of light.
The light-sensitivity of silver salts is the
magical aspect of photography, its dark
'natural' side. The optical manipulation
of light is photography's scientific trick.
The optical appeals to learning. It gives
the apparatus of photography a litera-
cy and a language which enables it to
experiment freely with the 'chemistry'
of metaphors and meanings. It locates
photographs within a literary culture. It
is not what a photograph shows, but
how it can make apparent the when
and where, by, of and for whom, why
and how it was taken, who it may be
seen by and where it is destined for,
that provides the picture with its liter-
ary reference. These 'visual data',

gathered and organised by the photographic lens, make it possible for (some of) us to 'read' photographs. But when the photographic imagination strives "to read or write... without reading or writing,"[4] it seeks, often in vain, to retrieve the 'alchemic subtext' encoded in the image in darkness by the invisible actions of chemistry.

As photography follows the path of technological innovation towards the ideal of pure optical perfection, more and more of the 'original magic' is being transferred from the image onto the enchanting powers of technology. And as the ideal of the perfect image is increasingly informed by the experience of the perfect machine, the ambiguous sense of illusion gives way to bewildered disillusionment. Behind the visual gratification of looking at photographs, there is also that kind of cold sadness which comes from lost

intimacy, betrayed faith, promises which have not been kept.

All this applies, at least in a limited way, to the experience of the associated uses of photographic technology in film, television or video, and in all manner of scanned or digitised pictures. Wherever the 'new' technology claims a photographic ancestry, at an ever growing distance, it also makes claims for the 'old' perfect image. And even where the image is made up of abstract binary calculations, our experience of photography can still catch a glimpse of the photographic impression dissolving into virtuality in the back-lit window of the computer screen. There still seems to be a faint reflection of the 'original magic' – at least in the self-conscious metaphor, where the mysterious workings of the silicon chip, enabling us to apply the secrets of the cabala to modern tech-

nology, meet language – as in the name of the 'most popular' computer operating system: *Windows*.

NOTES

1. 'Professional' and 'amateur' are slippery terms as well as extreme positions – for there is also the *par excellence* category of 'serious amateur' and even such a thing as a 'professional standard' toothbrush.

2. As with the 'red eye-eliminating' pre-flash cameras, for instance. In fact, it seems that the only thing most of us can still *do*, at least according to the manufacturers' promotional claims, is to buy the 'wrong' film, that is one which is not 'advanced' enough.

3. In the sense in which Jeff Wall coins the term 'dry intelligence' to denote the optical and mechanical aspects of the photographic process. (See also the text GARDEN, p. 86.)

4. This out-of-context borrowing from Ornette Coleman's notes for DANCING IN YOUR HEAD (A&M Records, 1977) is not as gratuitous as it might seem. Coleman is writing about the operations involved in playing the saxophone. In a basic mechanical sense, both the musical instrument and the photographic camera are controlled by the opening and closing of apertures to modify either the passage of air or the passage of light.

Edwina Fitzpatrick's BETWEEN THE LINES uses the form of a children's alphabet book. Twenty-six photographic still-lifes marked by the letters of the alphabet are juxtaposed with fragments of texts from THE EMPEROR'S NEW CLOTHES. Enlarged and unfocused lines of type in shadowy grey are overprinted by single words in black which may or may not have come from the original text. There are further references to the story in the photographs themselves: needles, pins, scissors, cutting patterns, baby soap and toys, theatre binoculars...

It all seems really quite simple. Andersen's pre-psychoanalytical tale is a story about the hold that authority has on the collective unconscious and imagination. It tells how imagination, the power to make something out of nothing, can be manipulated to unite us collectively in a vision of reality which otherwise conflicts with individual consciousness and perception. It takes the 'innocent eye' of a child to break the spell and make the crowd recognise the deception. It is not, strictly, a story of an anti-authoritarian revolt for such a revolt would require making a conscious choice between the feelings of security that collective submission to authority offers and the risks involved in taking responsibility for one's mental and emotional independence. The child's innocence does not know how to calculate the benefits and the risk. The child is independent not by choice but by not (yet) being able to conform to the dominant representations of reality. (Why else would any child give up the undeniable right of children to see a ghost rather than a pot-bellied naked man?) In fact, this kind of independence is but a matter of degree to which the 'innocent eye' is aware of the unreliability of perception, of the doubts and uncertainties which make it possible to reach the consensus through which, in turn, the invisible can be seen.

It is a tricky business to speculate on invisibility when it comes to

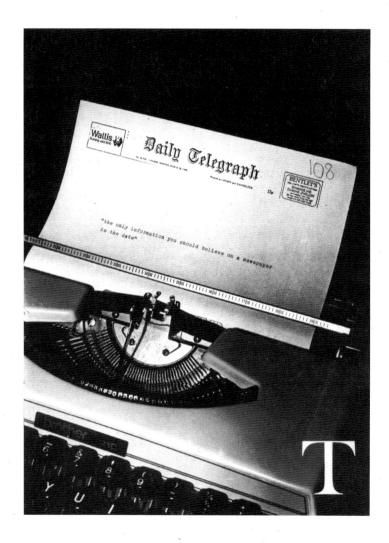

Edwina Fitzpatrick BETWEEN THE LINES 1986

pretended

themen of tl

in, fumbled

icking it up.

They dared

anything.

photography. The *speculum* of the photograph leaves all facts open to conjecture – but the discussion surrounding photography leaves no room for doubt: no transparency in photography, even less imagination. Like the crowd mesmerised by the spectacle of the forbidden sight, we all agree to see the photograph rather than that which it represents. We know that photographs, like fairy-tale emperors, are always only concerned with themselves. In our age of long lost innocence, it is impossible to see the self-facing mirror of photography as anything but a passive accomplice of our own story-telling, an instrument of fiction, of our desire to take both the image and perception for a ride. As with any mirror, the photograph reflects our way of looking, not just the object that we are looking at – the 'how' rather than the 'what' of that which is always unavailable to the 'naked eye'. In other words, it offers us that threshold voyeuristic experience of seeing ourselves looking without being seen. But at the same time, it only ever shows what 'everyone can see' and denies us the privilege of any intimacy: it excludes everything which is exclusive to us.

True enough, as we learn to repeat with others that A is for Apple and B is for Bear, at every stage of the process, more of our ability 'to see innocently' (as if 'for the first time') is eroded and replaced by understanding the seen through concepts laid down by the authority of perspective, optics and chemistry. By the time we have learned that Z is for Zebra we have developed a way of seeing the world the way others see it and have accepted as a practical truth the story told in unison by (and about) photographs. Though this may well be the only way of seeing of which we can also speak.

If we now want to point at something that others had not seen we can no longer innocently ignore the authority of the 'old story' (or reject it – overthrow the *ancien régime* of representation). We can only try to tell the same old story again. Once we know that the 'emperor is naked' – not because a little imaginary brat spoils the make-believe game but because Andersen has said so – we also know that he is wearing, at the very least, a very old hat. What can we do but add quotation marks to bend the rules by which we learn to read between the lines? How can we fail to catch a glimpse of the secrets of the invisible, as

long as we know that in every photograph the fabric of the naked emperor's new coat is woven out of old time-worn words? "My, look at the Emperor's new clothes! Look at the beautiful train he has to his coat! Doesn't it hang marvelously!"

— 1986

Black (and White) Magic

In some cultures, where the black and white magic of photography is feared more than death, people would not let themselves be photographed – their image captured by the camera, never to be returned; their beings split in two, the image behind the photographic surface, the imageless body in front of it. They fear being forever trapped in a body which, without its image, can no longer be the mortal body of the living but is already a corpse. Nothing that even death would take.

In our 'enlightened' world, where death defies all magic and the living and the dead are part of the same closed system of the image, our very existence is confirmed through being photographed – as if this surgical operation could make us more 'lifelike', as if only through being photographed we assume our identity and gain a place in a reality which looks increasingly like a photograph. With the shadow of photography permanently attached to our feet, we don't think of photographs as part of our corporeal integrity, rather we see in them manifestations of our existence as living images. Yet, somehow, we also know that the body in our photographs is really a trace of us.

Being photographed, when we are conscious of it, can be a strange sensation – part suspense, part vertigo. The magical attraction that the camera has for many when it is displayed in a shop window can turn into a distinct discomfort or panic when a photographer aims the lens at us. One moment it was an inanimate piece of technology; now, suddenly, it has become a part of another person – and not just a supplementary part (a tool or a weapon) but a kind of artificial organ, a completing part of a body which, until now, appeared to be much like our own. (Some manufacturers actually advertise cameras as 'part of you'.) This body is armed not with vision – the camera does not need to be put to the eye – but with the power to reach out. As the camera is pointing at us, we are engaged in an intimate contact with the body

of the photographer. Our smile, our self-conscious pose, are expressions of our simultaneous submission and resistance to the invisible touch. We are about to be seized ('taken', in the language of photography) by the hand with the camera, pulled in, coupled. It is not our image which we stand to lose; it is the privacy of our body being invaded, a threat of penetration (a theme often exploited in pornography), that makes us feel vulnerable and exposed.

In the photograph, the direct human interaction of the moment of photographing is replaced by the mediated experience of the image, physical intimacy reduced to a second order simulation. But the photographic image still bears a trace of that ritual communion with the body of the other united, for a fraction of a second, in the photographic act.

The main constituent function of any ritual is a unification of otherwise separate forces and identities. In both the social and private ritual of photographing it is the unity of 'subject and object' (or the unity of the body and the image) that is momentarily reached – a moment when imaginary and real existence are the same. The resulting photograph is present (albeit latently) already in the act: it is conceived in it ('born' afterwards from the 'body' of the camera). As it truly belongs to the fleeting moment of exposure, having taken on a life of its own, it can be seen as the moment's sole survivor – and where there is a survivor there must have been a close contact with death. And it is precisely the cycle of death-birth-rebirth – photographing is a reproductive process – which is at the centre of all rituals. The body of the photographer also leaves its trace in the photograph – not as an imprint but as an absence of a body of which nothing is left but an image from its eye's retina. This 'active' absence is what forces us to look at the photograph (we say we are 'looking through the photographer's eyes') and confirms that photographer was as much 'exposed' as the one whose body was registered on the film. Indeed, it is because of this that we might say that the body in front of the lens is posing with, rather than for, the photographer.

This is also why the word 'model' is so unsatisfactory when it comes to

photography. It is true that photography primarily draws upon visual concerns and ideals inherited from painting (think of the 'Nude' – and of the entire history of 'Creative Photography') where the body is celebrated as a model: universal, belonging to nobody and all, asensual, asexual, timeless and immortal. But in their desire for an idealised reference, these practices only underline that there is no such thing as 'the universal' for photography. A photograph of a model (as in fashion), regardless of all its possible intentions, is always an image of modelling, that is, a trace of a ritual staged around a communicative response between a camera and a particular person. The strenuous denial of the subjective specificity of the photographic encounter by the institutions of the market-place, including the photographic industry, as much as by many of their critics and commentators, is above all an attempt to impose on our bodies the categories and 'models' of the visual. This insistence on the autonomy of the image, the dominant mode of the photographic culture, serves to sanitise our self-perceptions, to banish the imperceptible and prevent the contamination of fantasy by the anxiety of absence which lurks beyond the threshold of the photograph. It is the transformation of the body into the image, its disappearance, which marks the authenticity of the photograph. But it is only the intangible trace of our participation in the photographic act that can ever authenticate that (magical) transformation.

In a world where photographic images have drained our mortal existence of so much meaning, and where photography has had such a dehumanising effect by making its subject both a thing and a ghost (the 'spectral mode' of our coexistence with photographs), it may well be that, in some sense, it is the human body rather than its image that has been trapped behind the 'mirror of the photograph'. The ritual of photographing is perhaps the closest we can get to the return of the magical or, strangely, to activating the conditions of a sense of existential affinity with the world denied to us by photography. (And this is where we must begin to speak about art.)

– 1987

The light in the gallery is subdued. An

elegantly designed panel near the entrance, adorned with Agfa's
logo and illuminated by a spotlight, describes the exhibition as
a diagram of photography's developments over the last ten years.
This is PHOTOGRAPHY NOW at the Victoria & Albert Museum and the
'now' of photography is the 'now' of the decade, the 'now' of the
1980s.

A Japanese girl is taking pictures of the works on display. She pro-
gresses unsystematically, omitting some, zig-zagging through the space,
never returning to the same picture. Richard Prince's rephotographed
'Big Country' Marlboro cowboys; Astrid Klein's large ghostly macro
photograph of fragments from other images; John Baldessari's com-
position of 'appropriated' soap opera stills. An advertisement from the
back page of a colour magazine, already a reproduction of a photo-
graph, remade by an artist into an original becomes a tourist landmark,
the subject of holiday snapshooting. The girl moves on. Cindy Sherman
modelling Issey Miyake's designs; Bruce Weber's black and white nos-
talgia for those lost days when boys looked good in suede loafers and
fin-tailed Chevrolets, a photograph of a bedroom ceiling lined with a
collection of pin-ups from Rambo and Abraham Lincoln to Marilyn,
Coca Cola and bath foam embellished tits'n'bums from a time before
masturbation became an issue in a political discourse. She records the
visual/verbal double pun in William Wegman's DRESSED FOR A BALL,
an instant (Polaroid) picture of a dog robed in brocade snapping at a
little red ball. (If, one wonders, it was Wegman who took the picture
of his four-legged companion, who then did take the photograph of
the artist himself hanging next? Well, it's only a joke; it must have been
Andrea, the young woman portrayed with the dog in the third pho-
tograph of a triptych entitled the Studio Assistant. Does the Japanese
girl notice the pun here?)

The girl loads her camera with a new roll of film and points it at the bust of Mercury in Robert Mapplethorpe's photograph. The picture's caption expands on the fine quality of platinum printing. (Surely not another pun – this time curatorial – on an alchemical transubstantiation of metals in a search for a 'photographer's stone'? Who knows; Mercury is the God of Gain, after all.) The girl knows that artists rarely make – and museums seldom buy – photographs on resin-coated paper. She read this next to the picture by Astrid Klein whose work is an exception to both rules. And yes, this is the very stuff her pictures will be printed on. No chance of becoming part of the same History of Photography for her souvenirs. History, as defined by the V&A, is reserved for images etched by light into a residue of precious metals and fixed in archival permanence – a history conditioned by the canon of conservation, by resilience to light.

The billboard-sized 48-sheet Benson & Hedges poster is far too big to fit into the viewfinder of the girl's auto-focus camera. She steps back, cautiously, so as not to bump into the glass display cabinet opposite, moves to one side and tries the view from an angle... then she returns to face the poster and presses the button. The image shows dozens of paper fans, a little like origami for giants. A detail will do; they will get the idea back home in Japan. The small black and white photograph left of the poster is much easier to take; H.M.S. Antelope hit by an Exocet missile in the Falklands war – shot, cowboy-style (as in Richard Prince), from the hip 'at a fifteenth of a second at f4.5'. She had seen it before, as had her family and friends, there was no escape from that image at the time. But is this really the same one? This must be the real thing, the first-hand account, the original silver gelatine impression. The exploding ship floats here in a sea of museum mounting board, an image made into an object, just like the Starn Twins' collage of creased, torn, stained and soiled prints stuck together with Sellotape and framed in gilded oak. A quote from John Baldessari explains this: pointing the camera at images, as she does, is the same as pointing it out of the window. Out there, things are pictures; here, pictures are things – small difference.

Pity there is not enough room to take a shot that would link all

three – the massive poster flanked by the corporate image from the Falklands campaign and Baldessari's ironic comment on the camera's relationship to painting in THE FALLEN EASEL. Pity too, come to think of it, that the curators had not thought of another of Benson & Hedges' past contributions to visual conundrums – the golden cigarette packet displayed as a work of art in a museum, remember? Imagine that, complete with its uniformed attendant, next to the white shadow of a distant fire-ball which left nothing but a small black patch burnt into the delicate surface of the photographic negative; and the painter's easel knocked over, it seems, by a trinity of men in business suits – the picture hanging askew as if about to fall off the wall! How about that for a 'diagram'?

The girl hurries on. There are so many pictures: the frightening human ants in a Brazilian gold mine covered in mud the colour of a gold-toned print by Sebastião Salgado; the annual family album get-together for Nicholas Nixon of his wife and sisters-in-law; Warhead, a kind of identikit computer composite of criminal characters from the Reagan-Brezhnev gang; a cherub-faced Texan boy with the intestines of a rattlesnake draped across his stomach by Avedon... and more upstairs.

This is an 'important exhibition' – the catalogue claims – the most important photography show in this museum since Sir Henry Cole presented his collection of fine photographic prints over a hundred years ago and swung open the doors of the V&A to photography. It will have been seen by "well over one hundred thousands visitors from all over the world." Appropriately so for a project that prides itself for being 'international' – which in photography seems to have come to mean not entirely North American. (I exaggerate, there are some Germans here, a couple of Japanese and British photographers, a solitary New Zealander, even a Brazilian living in Paris.) And it is said to be 'diagrammatic'...

That last adjective seems to be apologetically used here as a disclaimer of sorts, as if to suggest that the curatorial judgement had nothing to do with personal conviction and institutional creed, and was merely a matter of compliance with some self-organising order of

photography. As if the curators could have done no more than to present examples of 'some of the varieties of photographic achievement' which are currently on offer off the shelf, so to speak, in a metaphorical department store of our visual culture. It cannot stand. By definition, a diagram shows the arrangement and relationships of key elements and parts. Any diagram, a plan, a chart, a technical drawing, an instruction manual, even a mail order catalogue, explains rather than represents. A diagram deals in dispositions and tendencies, conditions and circumstances – like the computerised map shown to passengers on long flights to Japan, giving details of ground speed, altitude, outside temperature, flying time and the relative position of the aircraft to Bangkok, Rome or Teheran (and all those wonderful 'photo-opportunities' below). But a diagram is a pure abstraction, contained by its own code. It defines its object not by sampling but by modelling: substituting a theory for an existence.

From the diagram, it seems that 'photography' is constituted and held together by nothing but our obsession with classification. 'Photography' is no more than a label arbitrarily attached to photographs by those who live by diagrams. Indeed, 'photography now' can be seen only in a museum where the label shares identity with the exhibit. Where else could a disparate collection of photographs be turned into a schematic explanation of that which through its omnipresence can no longer be isolated? Outside the museum, photographic images have long seamlessly merged with the phenomenal reality of our culture (which they no longer depict but generate). So much so that the girl from Japan must be forgiven for thinking that the improbable spectacle of 'photography' constructed here is worth a picture.

(The editor of this magazine [CREATIVE CAMERA] tells me that after a century and a half we have arrived at a point from which on 'photography is dead'. He knows of course, that only death can guarantee immortality, particularly when it is by no means certain that the beautiful corpse displayed in the museum is not, in fact, a fragment of a body buried alive.)

– 1989

Roland Barthes'investigations into the speciality of photography[1] began with his doubts as to photography's very existence. In looking for the "evidence of photography, that thing which is seen by anyone looking at a photograph and which distinguishes it in his eyes from any other image," he found that the essence of photography its nature or genius – lies in the superimposition of reality and the past: 'that-has-been'.

This condition of photography "without which there would be no photograph", its singular strength and its limitation, concerns a disposition of things in time, an event. Each such event, however brief or distant, comprising any number of elements, is always unrepeatable, always unique, always different. The only common denominator of all such events is the involvement of the photographic apparatus. The 'that-has-been' is a situation of openness to the participation or intervention of photography, a situation of exposure. The event must be processed and developed into a photograph, fixed. It must be extracted from a continuum of events, isolated, marked, branded what Barthes was looking for is the stigma of photography – before we can speak of a photograph.

One of the first photographs, a heliotype by Niépce made around 1826, shows a table laid for a dinner complete with a loaf of bread and a bottle of wine. The choice and the arrangements of the objects, the overall composition of the picture are strongly reminiscent of certain paintings of the period. Unlike any painting, however, this is not an 'ideal' image of 'ideal' bread: this bread is real, a loaf of bread that we know existed. In this picture (on this table – like Lautreamont's umbrella and sewing machine – a chance encounter that takes place once in a millennium) the object met the image and gave birth to a new kind of reality. In the photograph, we have before us not a reminder of a past existence of the loaf of bread and the bottle of wine, their blurred

shadows, but their direct descendant, a continuation of their physicality in another object which is as real as they once were. A materialised view, an intangible thing, a bizarre contradiction, a 'mutant' to quote Barthes again, a 'new being'.

The table in the photograph is laid for one person. It is inviting, seen from the perspective of someone approaching it (and the approach is clear – there is not even a chair standing in the way). Yet this table, real as it is, will never be sat at, the bread will never be eaten, the wine never drunk. Not even by the person who was once standing behind the camera, the photographer, whose privilege of access seems to be stated in the image. Like a mirage, it will forever remain at a distance. This meal is then not a real meal after all. It is a photographic event, a kind of a spiritistic seance perhaps, in which the table is used as a focus for an encounter with the past. It is a ritual meal: the Last Supper of the Image which began at the very advent of photography, and in the course of which, as if by magic, one reality is being turned into another (water into wine) and multiplied (a loaf of bread which will feed thousands) ad infinitum...

40

In the 1980s' world of mega-visual communication, it could appear that the reality of photographic images/objects is almost the only reality that there is. By now, the world is to a large extent made of photographs. As if we lived in a multitude of parallel realities, time frames, separated only by the medium – through which there speaks the spectre, the ghost of photography. Like in a hall of mirrors, this is a world in which objects and images are becoming interchangeable.

Photography, the apparatus and the process, has profoundly changed the texture of this world. In its various capacities it has penetrated all its corners and affected almost every aspect of our lives. It changed the way we see the world as well as the way we resist its changing image. This 'luminous writing' has lead to a proliferation of testimonies – some of which in turn 'illuminate', to extend the metaphor, the stigma of photography. But in itself it neither says nor represents anything other than itself. In other words, it is photography that makes something 'apparent' but it is photographs that make something real: we see pho-

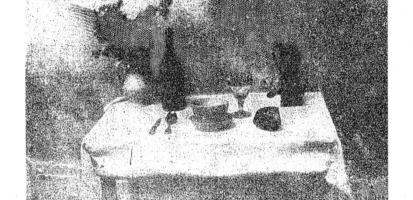

4

Joseph Nicéphore Niépce THE DINER TABLE 1826

tography but we perceive, study, handle and live with photographs. And it is the exact way in which each photograph slides between the 'real things' – the way the 'that-has-been' relates to 'that which really is' – that makes the world what it is.

This world is made of photographs, not of photography. It is not photography, not even the photograph (and certainly not the image – a generic term, it seems, from the realm of occult sciences), but photographs that make a claim on our reality. The photograph in this respect is always only the first one, whichever one that might have been, the celebrated moment, the point at which photography began to break down into photographs. The photograph is the First Event, the birth cradle not of photography but of the First Object, the first in a multitude of material facts, a kind of Big Bang. Since then what matters is not the unifying 'magic' of photography but only individual images, objects, events, the individuality of each of those things and their difference-in-repetition, even their 'sameness'. They may all belong to the same heterogeneous order, all the most distant relations considered, but they don't simply sprout by themselves from a family tree of photography, nor do they emerge fully grown from the subject matter with the photographic apparatus acting as a kind of mid-wife. They are made and used, each one separately, one by one.

In this world where our everyday participation has turned the photographic ritual into the most banal of routines, and where the omnipresent clicking of cameras has replaced a continuity of experience by the chaos of 'information blips', it is not possible to locate photography. There is no one large mirror as it might have appeared to Niépce when he realised that he was looking at his own reflection – the image of picture taking. Instead, there are only fragments of a broken mirror, in fact, a mirror which is continuously breaking, never diminishing, without ever having been whole. Angled mirrors, like those built into the so called 'reflex' cameras to enable you to frame and see the image as it will appear in print, their precise positioning, the specific way in which they reflect the world (the memory attributed to them by the contemporaries of Daguerre is of the selective kind) is what informs and confuses our notions of reality.

It has been said often enough that to take a photograph implies an act of appropriation: a spiritual appropriation of the seen together with the actual possession of the physical traces, the photograph. 'Taking pictures' certainly has more than one meaning. It can also be understood as 'taking a stance', an attitude, a bid for control, maintaining a distance, but at any rate positioning oneself within a photographic event. By extension, this means taking a stance in relation to each specific incidence. There is a plurality of positions: each time a picture is taken, someone assumes a particular attitude to a concrete situation which is taking place in the world of real things. Each time something is 'captured', trapped by the camera (by opening and closing the 'shutter'), someone marks a point from which a photograph is subsequently 'released'.

'Taking a picture' also implies taking a stance in relation to the living culture to which photographs belong: photographs are suspended events, but they are not suspended in a void. And it is precisely this positioning of oneself, a point of view, this attitude, that determines the way the photograph reflects back on the world of which it already is a part.

It goes without saying that such a stance can never be an academic one: we don't innocently observe photographs as they happen, we make them through complicity with a process of manipulation, with specific purposes and intentions. The most prevalent attitude is, of course, the vis-à-vis of a family album snapshot, an attitude which reflects directly back on the event, a pure 'that-has-been' or 'that-has-been-me'.[2] It says nothing else. But even so, it is an active engagement, always within, which acknowledges the specificity of the method and the material properties of photography but which must be ultimately concerned with the reality of the world outside the photograph. If the mirror of a photograph is to reflect the world in any meaningful way, it cannot be confined to reflecting simply photography as a subject in itself. It is not a question of various 'attitudes towards photography'[3] in terms of vocational preoccupations or professional interests, since this is no more than strategic manoeuvring within the abstract confines of the tradition of the 'photographic culture', an ideological

construct, a kind of shadowy underworld of worshippers of The Medium. Neither is it a matter of theoretical questioning which reduces its object to a mere specimen, for 'demystification' addresses the dogma but not the experience. (A photograph, a photographic event, is not something that is easily unsaid or undone.) Finally, it is not any rhetorical position either. It is photography that is wrapped in words, whereas photographs begin with silence.

Photographs are generators of stories, indeed 'incitements to reveries' (as Susan Sontag remarked) but, in themselves, they do not 'make sense': the story is both inside and outside the frame presented to the viewer. To address the world meaningfully through a photograph requires a rejection of the self-referential 'language of photography' in favour of a radical position, in the true sense of the word, which creatively displaces itself: with every subsequent fascination it severs its roots to confront anew.

Photographs are reflections of the world coexistent with its reality. To be of consequence, the 'superimposition of reality and the past' must be invested with meaning. This cannot be done by striving for new ways of representing the same (pointing a finger at that which already is) but only by creating something which would have not otherwise existed, not through photography but through a singularity of a photograph. And if we want to make sense of photographs, and through those of the world we live in, we must resist the non-sense of photography.

– MAY 1989

NOTES

1. In CAMERA LUCIDA, tr. Richard Howard, Jonathan Cape. London 1982.

2. 'This is my dog' or 'This is my house' in a family album snapshot should in fact always be read as 'This is me with my dog' or 'This is me in front of my house', which is exactly what makes family albums so exclusive.

3. ATTITUDES TOWARDS PHOTOGRAPHY was the title of a highly publicised exhibition mounted in the late 1980s by the Photographers' Gallery in London, which foregrounded some of the then fashionable themes, such as 'demystification', alluded to in this paragraph.

Roger Palmer takes pictures of signs. His pre-occupations seem to have crystallised in a modest text piece which provided the alternative title of the artist's exhibition in Salzburg: two words, 𝕭𝖊𝖗𝖑𝖔𝖗𝖊𝖓𝖊 𝕾𝖈𝖍𝖎𝖋𝖋𝖊 (Lost Ships), in a gothic-looking type-face the size of a newspaper headline, a faded grey-black image on a small piece of yellowed paper. It has the 'authentic' appearance of old newsprint, a scrap of the 'real thing', which has survived filed in some dusty archive or forgotten at the bottom of a dresser drawer to become history. Yet the words float strangely in the centre of the framed page surrounded by blank space, inexplicably isolated from their former con-text. (I am tempted, in my linguistic ignorance, to rhyme the word Schiff with the term Schrift: lost script or writing, the story announced here has long sunk into oblivion.) On closer look, the type turns out to be meticulously drawn in pencil, copied from a mechanically enlarged original. This, then, is not a line of 'print' at all, nor are the words sim-ply re-written, transcribed, replicated as 'text'; they are re-drawn, re-produced as a drawing. The distinction has quite profound – and profoundly poetic – consequences. Once it has become a drawing, the expression is much less a 'text', than it is a picture of words, a repre-sentation of the visual properties of a particular semantic object. It is made 'from life', so to speak, based on observation, a testimony to a physical involvement in the visuality of the world. As a drawing, Palmer's VERLORENE SCHIFFE are no longer ships reported lost at sea without trace many years ago but, metaphorically at least, these are traces of the ships' disappearance recorded as seen, encountered, in the mate-riality of language.

Another drawing – made in large letters directly onto the wall and taken, presumably, from the same fragment of front-page news – plays on the loss of the literary content, or its displacement, in the trans-formation of 'text' into 'image'. The words are presented as a self-complete

4.

46

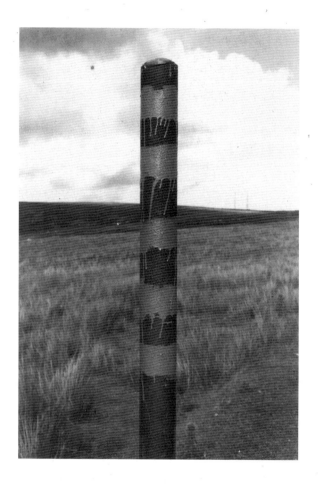

Roger Palmer 1992

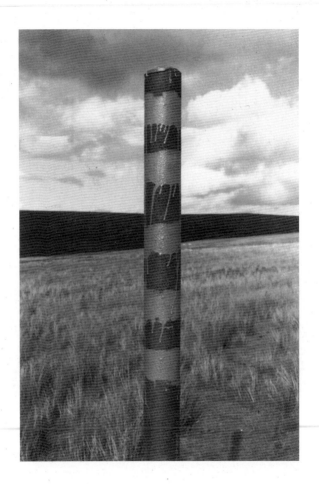

4

object, an accurate depiction of an isolated visual phenomenon, oblivious to the inner laws of language which determine the possibilities of language and its usage. They read in a kind of an ungrammatical telegraphic syntax, evocative rather than explicit: unbekannten Schiff zusammengestoßen. It is only through reading the work's title, (mit einem), that the expression becomes intelligible, (collided [with an] unknown ship). This combined visual/verbal statement is not ruled by the intentions of the textual message but by the actions of reading and viewing split into two independent operations.

A concern with the visual residue of communication is also evident in much of Palmer's photographic work. The pictures come in groups or pairs of almost identical images, some are placed so that they face each other as if involved in conversation, others side by side, inviting an active comparison of every detail. Two of them, taken in Namibia, are positioned either side of the entrance into one of the rooms in the exhibition. They show two hand-painted signs attached to a fence, oblong plates divided horizontally into two fields, reminiscent of flags or minimalist landscape paintings. Another set, entitled Discovering South African Rock Art, depicts detailed views of large blocks of granite, each stencilled with an identification number, weight and, as a trademark, a stylised silhouette of the springbok. The life-size scale of the pictures made it possible to view these markings as though they had been transposed as direct imprints from a South African quarry onto the gallery wall in Austria. Elsewhere, a solitary upright metal post, quickly painted with parallel horizontal stripes, was photographed from two very slightly different viewpoints. Hung on the wall at a precise distance, the essence of the territorial marker remains strangely unchanged by duplication: it marks the actual spatial relationship between the two framed photographs.

Using the mechanical means of photography, abstract figures ar objectified as visual traces and presented as communicative incidents. As with all images, 'reading' these signs requires negotiating the boundary between signification and representation. Yet in these photographs, the boundary is difficult to locate. Despite everything we know about photography, the pictures really seem to be what they represent. For Palmer

himself, "they establish their identity as wall-bound image carrying artifacts" rather than as pictures to 'look into.' In other words, in so far as they are of language, they are metonymic rather than metaphorical – pictures of signs as signs for signification. (In this, they also seem to resist the assumption held by common wisdom that the interchange between words and images increases thousandfold the metaphorical possibilities in favour of the picture. In Palmer's work, it seems, the exchange rate is 1:1.)

<div align="right">–APRIL 1992</div>

Shadow-Catchers

Had photography come into the world like today's cars, able to accelerate to their top speed in no time at all, had it not needed half a century to reduce exposure times from hours and minutes to fractions of seconds, it would have been named differently. We may have been talking about 'shadow-catchers', as the Cherokees ('People of Different Speech') once called the visitors with cameras. *Photography*, 'writing with light', is hardly a fitting term for a method of recording which has built its present-day authority on its ability to register the visual totality of the most ephemeral of fleeting moments at a click of the shutter. The *process of description*, of consciously grasping the world, defining its outlines with a string of signs, implied in the word photography, has been replaced by a micro-event too fast for the mind to experience. Now, when they are taken in the split of a second, photographs seem to be the random consequences of privileged accidents rather than works of gradual depiction – records of sudden glances rather than residues of long sustained gazes, images 'shot' or 'snapped' rather than slowly built, or traced, or drawn.

Or else, had photography taken a different route, had it not been chasing time for the best part of its history, the title 'Shadow-Taker to His Imperial Majesty's Court', which in a curly script seemed to certify the bearer's descendancy from the Rudolphenian alchemist underneath certain pictures of late nineteenth-century Bohemian nobility, might have not vanished with the Habsburg patronage. Indeed, the Germans (Němci, 'Mute Ones', in my mother tongue) have the archaic term *Lichtbildkünstlern* which used to describe photographers as 'light artists'. They were not thinking of the speed at which light travels, but of illumination – in the literal sense of 'lighting up', and perhaps also of the illuminated text, brought to the surface by the light touch of the artist.

But then, 'illumination', a technique of manuscript decoration in the 'dark ages', which according to Ruskin "admits no shadows but

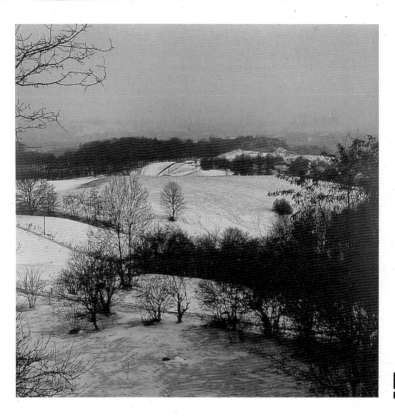

51

Cragie Horsfield SALWATOR, FROM KOPIEC
KOSCIUSKI KRAKOW JANUARY 1978 1991

only gradation of pure colour," is not quite the right image for the realm of images whose fascination owes so much to the solemnity of the black-and-white scheme that our culture has long reserved for the written word. Here the name 'photo/graphy' betrays an imprint of the binary schemes (and the binary nomenclature) which underwrite our understanding of the world – the elusive spectral light encrypted in black, the colour of the law (of the letter of the law, as much as the law of the letter).

Besides, the black shadow, drained of colour, is photography's greatest discovery: the shadow of the burnt speck of silver on the photographic negative – 'inscribed' by, and obstructing the passage of, light. Colour has made that inscription all but invisible – graphic, explicit, it has abolished the speculation necessary to turn recognition into revelation. Where the photographic chemistry has learned nature's chromatic trick of extracting 'pure colour' from gradations of lightness and darkness, another meaning of 'illumination' seems to prevail: 'to make easily understood'. Gone is the suggestion of the illuminated text, replaced by 'easy reading' (which 'admits no shadow' of doubt).

No shadows are admitted in darkness. In nature (whose 'pencil' produced Fox Talbot's 'photogenic drawings'), shadows certify to the existence of the real; in our photologic culture, like in Plato's cave, the shadow of the real is interpreted as the elusive threshold of perceptual truth. Our rationality is light-sensitive: seeing is believing. But to 'see' the images left by a brief flash of light in the shadowless darkness of the camera (and processed in a dark room) means also to 'realise' their transparent indifference to what we 'make' of the visible world. Here it is, a flickering hint, a momentary *impression* of a shadow separated from itself in a blink of an eyelid, closer to a dispassionate forensic trace than to an eye-witness testimony. The photograph: a 'signature of light' perhaps, 'written' at a single stroke like a comma or a full stop.Photography frames and retains; it does not articulate a 'text' nor tell a 'story'. It cuts through time without consequence. Yet, there still is a photography, like that of Craigie Horsfield, in which the 'process of description' can be thought of as a process of becoming. The solemn, deliberate stillness of Horsfield's photographs seems to be not of time

frozen in the past of the photographic image but of time postponed, held back until it is reclaimed – and celebrated – in the material existence of the photograph. For Horsfield, the photographic surface, although 'redundant' and "not engaged with the physicality of the world", is 'alive'. He believes that through the consideration of the photographic surface "we may experience the gravitational pull of the phenomenal world." This actualises the temporal experience of recording as an act of recovery. Speaking of photography (in an interview with James Lingwood and Jean-François Chevrier), Horsfield declares his working assumption that its language is 'imperfect', even 'corrupted'. But this is the only language he has – and he knows that it cannot be reinvented. Rather, it must be invested with a 'slow history' of understanding so that the traces of light gathered in the past can be reactivated to illuminate, for a moment, the picture of the world in which "we live at once, the dead with the living and the unborn" and which is "wholly conditional upon the present."

– 26 OCTOBER 1991

Portrait of LI Brezhnev

I use old discadded photocopies for writing notes and typing rough
drafts. As I put this sheet of paper into the typewriter, I see on
the back of it the smiling face of Leonid Ilyich Brezhnev. This
really is a funny coincidence /or, perhaps, something more than
that/: I was going to write about the diappearance of his
portrait.

In 1978 /or was it in 1980/ a friend of mine returned from Rusia

In 1978 (or was it 1980?), a friend of mine returned from Russia with a
photograph of a gigantic Brezhnev portrait in the making. In the pho-
tograph, the half-finished painting the size of a six storey building lies
on the ground in a Moscow square. On and around it, tiny human
insects, some carrying something, some equipped with brooms, are like
black spots on the surface of the photograph. Further above them (and
nearer to the observer – the photograph is a bird's eye view), crossing
tramlines or telegraph wires are reminiscent of the scratches on a reject-
ed photographic negative (like on those last photographs ever taken of
Marilyn Monroe and published posthumously, scratches and all). The

photograph must have been taken on a dark winter day, perhaps late in the afternoon or early in the morning. The ground, the air, the light itself is dirty grey, there are no shadows, and the only white is the freshly painted background of Brezhnev's portrait, the collar of his shirt and the white of his eyes. Because of this, and despite of the high vantage point from which the photograph was taken, there is no sense of depth. The perspective is distorted by the scale of the painting. Leonid Ilyich's face is like a reflection in a plane of filthy glass – a dusty and long unwashed window facing Nowhere.

At the time, the photograph seemed ominous in its absurdity. More recently, I have seen a number of photographs of crowds destroying or dismantling the effigies of communist leaders. The statue of Lenin hanging from a crane; huge Stalin's head on the back of a lorry; statues toppled and lying on their sides; suspended upside down in the air; paintings, photographs and posters burning or being torn. Most of those pictures were, or aspired to be, 'dramatic', to convey in a photographic shorthand the atmosphere of an irrevocable change fired by passion, hatred and hope. Yet to me, they were but variations on that desolate, grey, resigned, flat and stiff image of 13 (or 11) years ago which already then carried in itself its own destruction. Each time I saw a new image of a statue of a man in a long winter coat falling to the ground, each time I saw the heavy mass of concrete levitating above the heads of the crowd, it was as if the old picture suddenly moved, began to crumble. It was as if it became a film. Look, the tiny black figures are moving. Some faster, some slower, they move in all directions at once. The telegraph wires are trembling slightly in the cold air; the snow, at last, began to fall. The once so pristine ground of the leader's portrait is slowly turning grey with footprints, his face is losing its features and is turning into a large pool of darker mud. Gradually, all remaining contrast is lost and the image is now like a dirty and badly worn piece of blank film projected onto an old plaster wall in a semi-darkened room (the light bulb in the projector is also perhaps far too weak)... The image fades. And then (no matter how this is possible), it becomes completely black. The lights in the room go up but on the wall there remains a perfect black rectangle, toned in the purest of

blacks, velvety and deep. The ultimate photograph. If you look very hard and keep looking very, very long, and if you stay absolutely silent all the while, you may be able to distinguish first the head, then shoulders, then the whole silhouette of a man hovering in the middle, even blacker than the black darkness. It is a statue, large and heavy. Being erected. Being taken down.

<div align="right">– 26 NOVEMBER 1991</div>

Two photographs facing (figuratively speaking) a third define the entry (a figure of·speech again) into a complex world of figures, of symbols, of gestures, of indications, of inter-dependencies and multiple exchange.

The two – together for the time in the poetic space of an artist's project, rather than a 'pair' or a 'diptych' – are, for my purposes, exactly symmetrical. They mirror each other's movements, they metaphor – if there could be such a verb – one another. A large stone stands for a stretcher, a dark recess in the rock is a blind window, ashes of fire are synonymous with a radiator, a discarded, dead Calorgas canister is paralleled by a missing light bulb. One instant, the camera seems to have recorded a strangely shaped frame, half bench and half bed, perhaps an instrument of ritual torture or scientific investigation; an instant later it reappears, in the monocular perspective of a Polyphemus (a living camera) as the magical sign of the Pentagram and as charred stakes scattered on the floor... The two are, to me, two glances of the same image, the same object split in two by vision. This photograph, the composite image drawn here in words, made by superimposition, comes, of course, from no particular place and belongs to no particular moment. Like a double-echo preceding the voice, this is not (no longer) an 'object-as-nothing' (Plato's cave) but a figure trapped in its own reflection. This cave is hollowed in a void, a space of never diminishing resonance without an outer dimension.

"Enough is enough!", I hear my critics cry, "photograph without a source?!, trace without origin?, inconceivable!"... Yet I have already gone half the way and I must persist. Turning back would lead me precisely nowhere, for the exit is by now barred by a translucent screen – the third photograph. I must not let myself be misguided by the light shining through the picture. Note the condensation indicating the presence of an invisible layer, as impenetrable as the bottomless darkness

Jim Harold MASS OF FIGURES 1991

of the cave. Look carefully, it is the same image again – the same figure! – another symmetry, but this time along the axis of light everything is reversed. Overlay this on top of the corpus that I have constructed in my fantasy – it matches perfectly! Here, it seems, is the totality of the image – the positive united with the negative, the picture at one with itself, photograph enveloped in complete darkness (the purest solidified light).

Bear with me for another couple of lines and let us say, for the sake of (my) argument, that the *total* image faces simultaneously the world and the inverted body of the real. Like the body of a 'living thing' (conspicuous here by its absence) it is of the same substance as the world and exists only in reference to it. But, as with the body, the external world of which it is a part is no part of that which the image is to itself. Its being is a relative state, sustained from the outside by a transformation of that which *is* into that which *it is* and, from within, by continuously returning itself into something which *it might be*. Being and becoming separated by Nothing.

The dimensionless plane of this exchange, the site of my metaphor, that which I have named Nothing but which may equally be called the Photograph, transparent and opaque at the same time, is formed of sliding layers (the real and the imaginary, the known and the perceived, the literal and the figural...); and it is only through shifting and repositioning the transparent and the apparent (an operation initiated in thought and performed by poetic imagination) that a figure of the real can emerge from a Limbo on the threshold of light – a contour of the invisible, the non-existent for which there is no evidence and no measure, but without which our vision of reality would become meaningless.

– CHRISTMAS 1991

There is not a better illustration of the photograph's unconditional attachment to a particular moment than the stock-in-trade shorthand used by film-makers: the freeze. This somewhat tautological device capitalises on the photographic pedigree of the 'motion picture' as it demonstrates that film is a sequence of photographs in their raw state, shown as taken at 1/32 of a second. Easy to double-bluff the disbelieving eye: one moment, the fusion of images and afterimages, rapid dis/appearances, leaves the impression of continuous motion; next, a succession of a few identical frames flicking away in front of our eyes with exactly the same impatience suggests a still 'photograph', as if pointed out to us by the director's finger stuck in a flip book. (With the freeze, the cause seems to be the effect.)

A painting or a drawing cannot be so naturally 'revealed' in film. The black bars of unexposed photographic material excepted, film conceals nothing but photographs. All those *other* still pictures have to enter the cinema screen, in a creepy kind of way, from somewhere outside photography. The slow dissolve is the appropriate trick here: a view from a window of an artist's studio slowly turns into a watercolour sketch or a map dissolves into an aerial view of a landscape. A similar treatment can even be used when it comes to showing a photographic *print*: an image gradually emerging from the red glow of the darkroom safety light on the surface of a *piece of paper* submerged in a tray of developer. But the photograph *as a photograph* is invariably portrayed as a sudden disruption. In Antonioni's BLOW UP, which features some of the most notorious and ecstatic examples of the cinematic licence ever applied to photography, the distinction between the photograph and the photographic print is precisely stated by the use of the two clichés. The 'photograph', always a picture-in-the-taking, is expressed by a brief suspension of animation, sometimes of colour, that is, by the suspension of film. And while it cannot be denied that the 'show goes

on', that the film is 'still there', it is quite apparent that it has skipped a heartbeat, as it were.

Superficially, especially where it is accompanied by a flash of light or the sound of the camera shutter, or where a crescendo of 'shots' appears in a rapid succession, the frozen (or is it *freezed*?) 'photograph' seems to belong to the same dramatic vocabulary or cinematic punctuation as gunfire. It shows the photograph's complicity in the dramatic action. (To paraphrase Robert de Niro in THE UNTOUCHABLES, it comes from a neighbourhood where they say you can achieve more with a kind word and a photographic camera than just with a kind word.) But on a deeper level, the shooting of the photograph is cinema's true fatality. It betrays the impossibility to accommodate in the 'movie' the *rigor mortis* of photographic stillness. (Worth noting that the only alternative purpose for which the freeze appears to be fit is the very last shot of the film, THE END). The freeze is cinema undone.

The suspended still image is an isolated incident, a parenthesis, both absorbed into and extracted from the passage of time. It issues from the action, from its logic and from its flow, but it never returns to it. No matter that after the incident the action resumes – a body caught in mid-fall by the fictitious photographer hits the ground, for example, or colour returns to a black and white still picture of a landscape – the story is never the same. A permanent transformation has taken place while, for a fraction of a second, we were not *watching* (quite literally – with our eyes on the screen, we were *looking at* a 'photograph'). The chronology of events had split into two parallel but asynchronous tracks and the story 'jumped' from one onto the other.

For the photograph, there is no 'after.' It belongs exclusively to a single moment, always in the past, always gone even before it becomes visible ('developed', 'fixed' – the real time of a photograph in the technical terms of film is the single frame which the eye never sees). During the freeze, 'time stands still' as if waiting, in vain, for the photograph to *retrieve itself*. But in the 'still time' no 'past' can be located. This is why the sudden motionless apparition on the screen is not, in fact, a photograph but an image of its absence – like a hole in the chronological gap.

(Of course, there is also another way of looking at this: the freeze is a simple role change. For an instant, we are privileged to look through the camera – as though we hadn't been looking through it all the time – and see the film crew making a pause for a pose.)

– DECEMBER 1991, AFTER WATCHING Blue Velvet

4

Two stories told in photographs: each narrated in a different tone, each written with different light. One is self-consciously posed and flamboyantly staged, a stream of brilliant colour enhanced by a few black and white interruptions; the other is composed of delicate monochrome images floating in darkness. The first is melodramatic, dominated by theatrical gestures and ornamental scenery – a costume drama in every sense of the word, propelled at speed through a succession of sudden twists and turns towards an abrupt freeze; the second describes in a single hypnotic slow-motion sweep an evanescent moment, a vision so unstable and volatile that it dissolves even before the eye can focus.

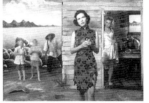

The story of SOMETHING MORE (placed in Back-of-Nowhere) is a fantasy of escape. It speaks of a desire to move 'forward' and 'up' (to the social highs and riches of Big City). The second story, PET THANG, suggests a movement in an opposite direction, a return, a recollection of a dream, a descent into some deep subconscious world. The former is articulated with the directness of a cartoon strip; the latter is wrapped in half-lit mystique.

The same young woman appears as the key protagonist in both: once in a role (and a dazzling red dress) borrowed from the stock of minor-key 1950s' Hollywood stereotypes; and once as an archetypal figure from some early volume of C. G. Jung. In either guise she embodies an image for a scenario of transgression...

In a version published in 1990, SOMETHING MORE is set in motion by an outburst of words scattered like a deck of tarot cards: *Aspiration, purpose, wish, hope, desire, intention, goal, good omen, good auspices, promise, good fair of bright prospect; clear sky; ray of hope,cheer, silver lining; Pandora's box; pie in the sky; castles in the air or in Spain,*

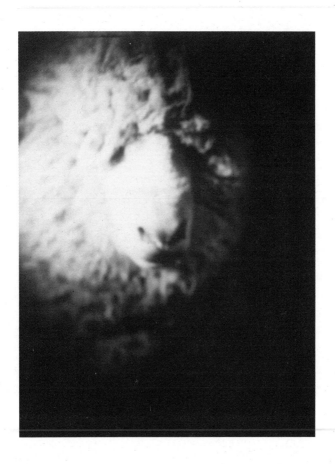

Left Tracey Moffat EXTRACTS FROM SOMETHING MORE 1992
Above Tracey Moffat EXTRACTS FROM PET THANG 1991

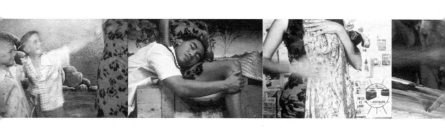

pot of gold at the end of the rainbow, Utopia, Millennium, hope of

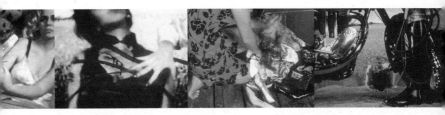

Heaven, daydream, airy hopes, fool's paradise, mirage, end resolve, zeal.[1]

Each expression linked to the next without syntax, a mere string of nouns, a range of sentiment or feeling, pure context. Words, flickers of meaning, like the frames of a film rattling through the gate of a projector: their separation and their unquantifiable differences create an illusion of movement.

A similar 'kinetic' or 'stroboscopic' effect seems to occur in the nocturnal metamorphosis of PET THANG: less a progression of events steered by causality than a line of near equivalents (a recurrent dream). Like an entry from a kind of a visual thesaurus, this is a catalogue of difficult-to-define shifts and changes, temporal fragments punctuated by silence. Here, beyond any difference of style, mode (model), colour or tone, is the single unifying metaphor: desire trapped in a flow of images, kidnapped, seized – raped in the true sense of the word – by the machine of animation. The fantasy of transgression is repressed to voyeurism – and voyeurism is consumed in mechanical *bestiality*, driven by the clockwork of The Cinema.

The metaphorical essence of the cinema is the *frame*. In the first photograph of SOMETHING MORE, the heroine's eyes are focused somewhere beyond the edge of the cinematic 'reality', her attitude expresses 'hope' and 'confidence'. Does she know that she faces certain mutilation once the reality of the cinema has taken over from the still image? The invisible gaps between the frames, the space for fantasy, are measured by the relentless pace of the film. There is no escape. It takes only the shift from the first photograph to the next, one click of the camera shutter (a miniature guillotine) and we shall never see the heroine's face again. The confrontation with the cinema returns a body decapitated by the edge of the frame.

The (headless) body is, in turn, surrounded by images from the realm of sadomasochistic erotica (the initials S/M in the title should have been read as a warning).[2] A gleaming motorcycle, a pair of riding boots and a whip literally frame the body crouched on the ground, while the bondage tying the body to a chair (another kind of a frame) criss-crosses the picture like lashes of a whip, violent scratches or cancellation marks.

In PET THANG – a title chosen by the artist for being 'slangy, almost

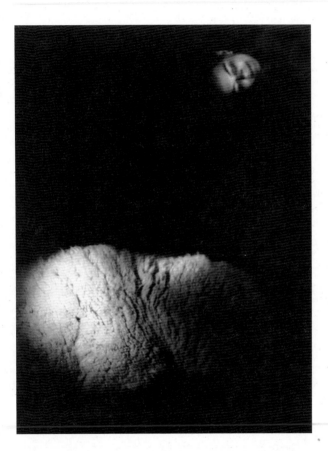

pornographic' – the body is fragmented and dismembered just as vio-

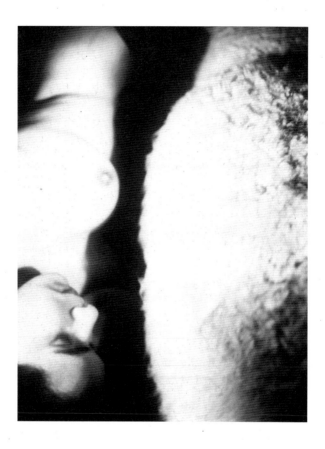

lently: the head in one, the torso in another frame. In one instance,

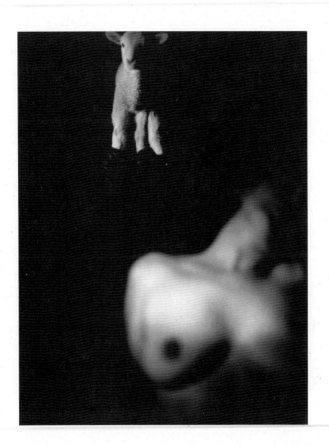

the deep green tone of the photographic prints changes to a reddish

pink and the body appears head down, like a piece of meat hanging next to an animal carcass. Elsewhere, in what at first appeared to be a picture of 'natural simplicity' and tenderness, the surrounding darkness hides again the paraphernalia of sadomasochism: a pair of hands in black leather gloves holding a lamb by its legs.

And, as the flip side of the same metaphor, the fragmentation of the body parallels the disruption of the perceptual unity of the 'real' cinema – 'real fiction' – when, as it is here, the 'film' is shown frame-by-frame. The apparatus of power is violated, the illusion shattered, the spectacle turned up on itself in 'suspended animation'...

When all is said and done, the narrator herself is absorbed into the fiction. Her identity (her desire, her ambitions) are tied to the same conditions and conventions which provide, maintain and control the image of 'our' heroine. To tell 'her' story, she identifies with – and negotiates her place amongst – the *dramatis personae* of 'our' culture. In her dual role as both the animator and the (passive) object of voyeuristic fantasy, she challenges our collective claim on those images, models and stereotypes and, simultaneously, she acknowledges their dominance. As she confronts the imaginary extremes of power and constraint, she knows that the fantasy of a mastery over the illusory world of fiction, and a submission to it are inseparable from each other and must ultimately negate each other. At the end of SOMETHING MORE, the lifeless corpse lies flattened against a two-dimensional pathetically unconvincing backdrop. In the final picture of PET THANG the face is blurred, the eyes are shut, the light is low. Is she asleep? Is she dead?

– APRIL 1992

NOTES

1. NEW FORMATIONS, Spring 1990.

2. The 'coincidence' between some of the imagery and the initial letters of the title SOMETHING MORE was pointed out by John McDonald in a review in THE SYDNEY MORNING HERALD, 2 September, 1989.

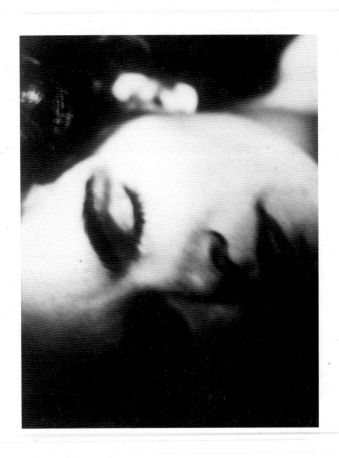

14

11.
The Finger-Print

Forensic evidence registered on the same plane as the ghostly trace of the distant photographic event. How did it come to be a part of the story? The prime suspect (and the key witness) is certainly the photographer tampering with history. This faint trace of touching might either have its origin in the preparatory operations preceding the taking of the photograph (touching is the foreplay of seizure), perhaps in the coating of the clear glass plate with the layer of photo-sensitive chemicals or in loading the camera, or it might have been left after the event, during processing or printing. But others might also be implicated: archivists, researchers, civil servants, army officers, journalists, flea market traders... – anyone handling the picture (re-visiting the scene, so to speak) at any time during the last three quarters of the century. Or, again, it might be that the finger-print marks the current ('second') negative, the one from which these (re)photographs have been made. At any rate, the finger-print so clearly present here is asynchronous with the photographic image.

This accidental mark confirms a paradox of photography: wholly composed of the material residue of a specific, singular incident in the past, the photograph (not the 'image' but its dimensionless 'site,' acknowledged here by someone's careless handling of the negative or of the print) is always anchored in its own history rather than in time.

Tim Brennan EXTRACTS FROM FORTESS EUROPE, NO. 11- 42 1992

The Sky

'Low cloud hindered observation from the air.'[1]

On the glass plate (governed by the order of chemistry and optics), there is a veil of blackened silver salts, burnt-out and charred sky, blocking the passage of light. But in the photograph, (where history makes its claim) only a blank plain invites speculation.

The sky so dear to painting (plumes of smoke, baroque swirls of clouds, red glow of distant battles) has left only a trace of its absence in the photograph. As if the sky had never recovered from the night. As if even Gods had turned away. (Picasso's electric lamp in the shape of an eye, painted, in despair, in the tones of black-and-white photography over twenty years later, is painting's plea for the return of divine 'observation from the air.')

'Rain set in about 11 a.m. on the 2nd October and continued to fall with little intermission through the two following days.' The image has become hostage to illusion as the downpour washes away the fragile emulsion.

27.
The Spade

An instrument of excavation – that is to say, an instrument of image-making: to excavate is to make an incision through visible facts, to expose to view. Spade in hand, the excavator is re-modelling the known, de-creating the familiar so as to uncover something which has existed materially but was not available in the phenomenal world. It is, no doubt, the thing itself that the excavator desires, its presence, not its reflection or its trace. But excavation is not just mining, nor is the excavator just a prospector. Whether for profit, or in a quest for knowledge – small difference – the excavator wants to renew the past. Like a photographer (with whom he also shares the process of the negative/positive reversal – for what else is a dig than a mould?), the excavator is a collector of fragments salvaged or extracted from disappearing wholes – just as much as he is a perpetrator of such disappearances. The intention is to return the past to the present. Yet, cumulatively at least, the enterprise of renewing the past inevitably succeeds only in undoing it: fabricating incongruous juxtapositions of isolated incidents, parallel re-appearances, in a word, images.

(The spade, of course, is also a grave digger's tool.)

32.

The Dead Man

Photography is dominated by amnesia: not by forgetting, but by an impossibility of recollection. The past, the very matter of the photographic image, cannot be recovered from beyond the horizon of the photographic event – the image is always a fatal accident, an end, a terminus, an exit point, never the point of entry.

41.
The Grid

The photograph (this photograph, the source of these fragments) has been divided, partitioned, into thirty two segments. Four rows of eight upright rectangles, all of the same size. In the photographers' jargon, the upright format is conventionally referred to as the 'portrait.' Thirty two portraits then? (By some unexpected coincidence, the number actually corresponds to the number of figures discernible in the photograph!) But if this is so, then the photograph must be recognised as a metaphor, something which it is not.

The 'features' of each of the portraits, the 'shape' of each 'frame,' are ruled by the regime of geometry. Moreover, the pictures are numbered, arranged in a sequence – picking up from where a previous body of images left off and indicating both a potential totality and the impossibility of ever reaching an end. These arbitrary fragments of the particular have now been assigned positions within a project designated to give a shape to history. Parading in front of our eyes ('The troops were said to have advanced in splendid order'), is no longer the past but our own feeble and frustrated attempts to locate it through photographs.

(Is this why it so often seems that certain images ceaselessly repeat, to those who ask, 'the end of world has been and gone?')

– SEPTEMBER 1992

NOTES

1. All quotations in the text, printed in italics, are from MILITARY OPERATIONS, FRANCE AND BELGIUM 1916: 2ND JULY 1916 TO THE END OF THE BATTLES OF THE SOMME, compiled by Capt. Wilfred Miles, Macmillan, London ,1938.

Garden

In an excellent essay on the work of Jeff Wall,[1] Thierry de Duve discusses the artist's debt to the project of Manet and the 'way of seeing' of Cezanne as an aspiration to an ideology of beauty which remains true to modern life while rejecting the utopian perspective of modernity: a beauty which makes no promises for the future but 'whose brief and flashing memory is to be seen shining out at a moment of peril, in what Walter Benjamin called a dialectical image.' Wall's work is not just a critique of modern painting by photographic means, turning pictorial concepts and conventions inherited from painting's history into a metaphor for the immanent features of photography. Rather, the complex historical relations of painting and photography are themselves the medium through which the modern dialectic of beauty can be articulated. The essay concludes with the distinction that Wall makes between 'liquid' and 'dry intelligence' in photography – its chemical and its optic and mechanical aspects, its alchemy and its geometry, its 'nature' and its history and inevitable digital future. If it is the former that keeps photography aligned to the trajectory of painting and its modern aesthetics, then it is the latter that imposes on it those didactic 'literary' obligations which modernist painting has given up in the name of self-examination of the medium driven by 'historical necessity.'

In three of the four sets of photomontages in a series entitled GARDEN, John Stezaker has used reproductions of photographs from turn of the century 'surface anatomy' manuals, designed for the study of 'life' drawing and painting. Each work is made up of two halves of different images spliced along a vertical seam. In some instances, the same source image is repeated several times within the set or the front and back views of the same model are combined. THE CROSS, a sequence of five full-length figures with outstretched arms, for example, brings together five ballet-like poses of young man and woman with a pic-

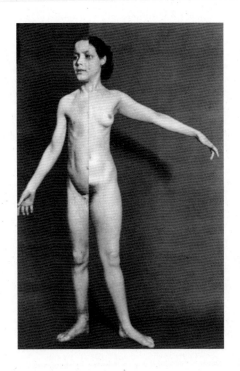

John Stezaker EXTRACTS FROM THE CROSS 1994

ture of a pre-pubescent boy. The diptych EXPULSION shows two male/female pairs of legs caught in mid-stride, while FALL is a set of life-size mix-and-match torsos, held together by a sharp straight joint in place of the spine or breast bone.

The works produce curious mutations which bring to mind Victorian 'scientific' manipulations and uses of photography: Siamese twins joined at the hip and shoulder like a living Rorschach blot. They suggest both a pathology of photography and an open verdict on the (Edenic) myths of origination. But above all, they problematise, by the most economical means, the ideal of the human form as a site for aesthetic pleasure born from the imposition of geometry onto visual perception.

Even more successful, if less spectacular, is the set of pictures showing the lower parts of tree trunks, made by reversing half of the photographic reproduction along the vertical axis so that one side mirrors the other. These too are torsos of a kind: torsos of images as much as imaginary human torsos in which the cracks and scars in the texture of the bark are reminiscent of the navel or nipples. In contrast to the anatomical dissections of pictorial sources derived explicitly from the history of art, the figures hidden in the TREE works are extracted from images of uncertain origins and destinations. As it is impossible to guess which half of the symmetrical picture corresponds to the orientation of the 'master' image, the concepts of 'original' and 'reproduction' become interchangeable, creating a space in which imagination can recover in the ghostly apparitions a sense of archetypes lost by the history.

De Duve's essay and Stezaker's exhibition were brought together here by accident (reading on the Tube on the way from the Whitechapel to the Cubitt Gallery at Kings Cross). Why did it seem an appropriate starting point? The references to painting in the GARDEN are quite unlike those that resonate throughout the work of Jeff Wall. Where Wall's photographs emulate painting with the techniques and technologies of photography, Stezaker's are dead-pan quotations of 'paintings' yet to be painted; where Wall insists on the pictorial unity of the tableau, Stezaker rejects such a unity in favour of the hybridity of collage; and where Wall alludes to an iconography informed by the modern paradigm, Stezaker comments on the conventions of academicism.

The 'dry' optical 'intelligence' of Stezaker's images acknowledges the 'impossibility of painting' without surrendering to fraudulent promises of photography. His pictures are fallen 'paintings' expelled from painting by history; and they are photographs severed from photography by the conceptual sharpness of his incisions. Like the perfectly aligned eye of his half-child, half-woman hermaphrodite looking disconcertingly over the viewer's shoulder, they reflect a memory of the beautiful in the grotesque.

– APRIL 1996

NOTES

1. Thierry de Duve, 'The Mainstream and the Crooked Path,' JEFF WALL, ed. Iwona Blazwick, Phaidon, London 1996 (published to coincide with the artist's exhibition at the Whitechapel, London).

Virtual Confusion

With the arrival of 'virtual reality' the sell-by date of the future is no longer 2001. Flanked in the dictionary by 'virtu' and 'virtue,' the term itself has caught the imagination of the visual arts community with a sudden sense of urgency. No matter how we see the world around and ahead of us, and no matter how much we've become used to the perennial invasion of the 'new' (or how cynical we have grown about the unfulfilled promises of past 'innovations'), this greatest challenge to the mechanical principles we've lived by for centuries calls for an imminent radical change in the way we think of the image. But as the essence of our visual culture threatens to become obsolete and we are trying to imagine the shape of an imaginary 'reality' beyond illusion, both indistinguishable from the 'real' one and totally different, our minds are experiencing serious confusion. Among those of us involved with the visual arts, not many seem to be sure just what is so new about these 'new images.' Even fewer seem to be certain just how 'real' – or how 'virtual' – these 'images' really are. The concept of virtual reality does not merely pose questions to reality – such questioning is the mode of the image – it puts the imagination itself on trial.

We have learnt to assume that reality underlies all appearances, images and concepts; it is the 'real thing' of which the image is a double, a surrogate. Much as we (some of us) would like to believe that through their omnipresence and inflation in this techno-scientific world, images have lost all signifying connections with reality, we still know that it is 'reality' which gives substance to the image's loss of signification. Reality surrounds every image. Every image, even the purely 'abstract' one, has to negotiate its relationship to facts, phenomena, mechanisms and processes external to itself. For even 'negative representation,' as Kant called it, is representation – the image still demonstrates existence.

The 'new (virtual) image,' however, constitutes a complete world of its own. It submits happily to the authority of the natural order of cause and effect (hence it is not an illusion) but only inside its own self-perpetuating system. It doesn't seem to reflect or 'represent' anything outside itself. Is it then an image at all? It certainly is not a trace-image, an image-as-we-have-known-it, from cave paintings to photography and video, which bears witness to a particular physical event and comes into being through a direct contact with pre-existent reality, matter or energy. It is not an image of something, a duplication by recording. Rather it is a relative numerical simulation, a matrix-image – a mathematical model, a formula made visible. The constituent components of this 'image' are interdependent numerical quantities, infinitely modifiable relationships of values in constant flux. Thus the 'virtual image' is a liquid image, a visual state of a language ruled by the principles of the calculus.

It is true that the language in which the matrix-image creates itself is a highly formalised system of abstract symbols, but it is a language all the same, a code. Yet, a strange paradox is at work here: this 'image,' created as it is in a language, does not appear to form a message which could be received and decoded. Instead, it exists as a field of data in a kind of dialogue with the viewer/participant. It is not received, but entered into like conversation.

Things being what they appear to be in cyberspace, it would seem that the direct, non-sensory interactive participation demanded by the virtual 'image' should be a purely interior adventure. The dialogue with the model does not require any consideration of the exterior world (just as it is of no direct consequence outside its own digital framework). For as long as the system is in operation there seems to be no distinction between the 'virtual' and the 'real.' Yet, any interlocution is an encounter of at least two identities (the kind of exchange from which images are born – one imprinted on the other). In the digital intercourse, the two identities are linked, become parts of the same system, but since the dialogue requires polarity they cannot merge into one. Presumably, this dialogic mode will always retain at the very least one external referent: the actual identity of the viewer/participant,

complete with the norms, beliefs and uncertainties which determine our perceptions of the world. And so our interaction with the digital designer universe of 'virtuality,' the techno-nature of our own making, will produce a meta-image: the reflection of our feeble attempts to make sense of the world we actually live in (and to formulate our reality in images).

– 1994

A Shadow of the Crowd

On the one hand, it is still possible to speak of the presence of sculpture in the contemporary city in the 'objective' terms of time and space; on the other, any discussion on the role and function of such material manifestations of creative or artistic interventions in the physical environment must, sooner or later, turn towards the question of the conceptual, technological and logistical conditions which determine their perception. Central to this will be the question of collective public interaction for which public sculpture, in a historical sense, provided both a possible focal point and a means of regulation (as an expression of legislative power or authority, as well as part of an overall spatial or environmental scheme).

It could be argued that with the advent of modern communication media, particularly photographic and digital image technologies, and the consequent necessary changes in the demarcation and self-perception of the 'public domain,' the primary role of public sculpture may have become substitutive rather than communicative. (It stands for, rather than says, something). Instead of being a physical 'marker' of collective interaction, it has become the last symbolic reminder of the absence of 'the crowd' from the conceptual 'space' of the contemporary metropolis.

1.

The crowd is both a product and an active agent of the urban milieu. The notion of the crowd is virtually synonymous with the dynamics of the modern city which facilitate circumstantial concentrations of collective activity and which are, in turn, affected by the constant necessity to regulate and absorb such activity.

Yet, it is possible that in the contemporary western city the crowd can no longer be perceived

Pavel Büchler
THE VOICE OF THE
PEOPLE 1991

as a distinct formation – that it is no longer distinguishable from the forces that it is ruled by – and that it has been diffused or dispersed throughout the demographic and social structures of the city.

2.

The disappearance of the crowd, its dissolution, is a result of changes in communication and perception which parallel the shifts in technology and economy by which the post-industrial urban society sustains itself; from sequential modes of communication and exchange to the mode of instantaneous contamination – or, seen from the perspective of the crowd, from a participation in a process to a random exposure to effects and products. Both the historical and the geographical coordinates of the crowd (its 'time' and its 'space') have been radically affected:

> The early modern city was steeped in an indirect conception of time, where time could only be derived from the experience of succession and simultaneity of phenomena in space. The contemporary metropolis, however, informed as it is by the irradiative model of instantaneous contamination of entire regions or populations, embodies a dramatic alteration in the conditions of perception. Space is now suddenly condensed, and time, rather than passing, exposes itself.[1]

3.

The effect of these changes on the state of the crowd can best be seen if the crowd is considered not as a social configuration, governed by general socio-economical laws, but as a conductive field of inter-relationships among individuals – a medium of communication – particular

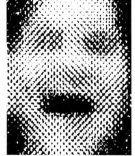

to the conditions of the temporal and spatial relationships which occur in the contemporary city.

4.

The most visible feature of the crowd understood as a medium of communication is the ripple effect caused by the spreading of information from an

individual to an individual through direct contact (like a rumour or a virus).

The crowd is, undoubtedly, a symptom of activity: a shape of an event. It is formed and held together by a response to external stimuli. Our everyday anthropomorphic vocabulary unites such a response into a single 'body' and one 'voice.' But the seemingly immediate reflexes of this 'body' only trigger off further complex reactions involving large numbers of individual relative operations. A round of applause is a typical example: it erupts (almost) instantaneously as a direct 'corporate' reply to an outside impulse but it develops, breaks up, and eventually comes to an end through mutual interaction among the people in the crowd.

5.

Information spreading throughout the crowd is, as in any system, subject to friction, entropy and absorption. But because it spreads through active contacts among individuals, through constant re-coding and re-formulation in a continuum of social exchange, the inevitable modulations and mutations of the initial impulse facilitate an awareness of collective interdependence as they affect the very social bond on which the transmission depends: the flow of information is conditioned by a mediation of immediacy.

Thus the internal cohesion of the crowd and its existence as an active agent are determined by the individuals' experience of their participation in a collective transformation of information into knowledge. 'Being there,' in a place and at a time, means sharing in the power to transmit, that is to say, the power to transform.

6.

The crowd has no centre. There are no firm points (and no fixed hierarchy) in the crowd, only an external shifting focus which becomes internalised and ultimately dissolved in a process of continuous mutation.[2] Information travels throughout the crowd from a more less random point of entry in all direc-

tions at once generating a wave of response and affecting gradually the overall state of the crowd.

However, a mode of transmission which can neither be regulated from a centre (because such a point cannot be isolated within the 'system') nor coordinated externally (because any external focus is always created only by the gaze of the crowd itself) is inevitably unpredictable and uncontrollable – and potentially disruptive to the 'normal' functioning of social mechanisms.

7.

As a controlling measure the modern society has therefore introduced a whole array of technologies and standards aimed at systematising, synchronising and simplifying the functioning of the basic components of the 'system,' the relationships among individuals: from legal provisions governing the rights and social obligations of the individual, through health and safety systems, to the system of education and professional qualifications, urban planing and coordinated design, standardisation of working hours and leisure time etc. While these measures do not eliminate the transformative powers of the crowd, they do nevertheless enable external agencies to control the spreading of information, its radius and its influence, more efficiently by allowing them to predict and locate with some accuracy the moments and points at which the process of transmission can be interjected, polarised or disrupted. Indeed, these measures can effectively be used to turn the power of the crowd to transmit and to transform into the means of self-control.

8.

Yet controlling the 'system' through selective regulation of the social contact among individuals is not only too slow but, importantly, it requires the individual inter-personal links to be maintained. To be effective, the regulatory principles must be integrated into the process of transmission itself in such a way that, for example, criteria of interpretation pre-

cede information, or ready-made 'facts' strategically coincide with 'common knowledge.'

It is only when an external agency can reach every individual simultaneously, that the active social interrelationships become redundant. Modern mass communication media provide the necessary conditions: a contraction of distance through ultra-rapid transmission, massive scale of operations, and the anonymity of de-humanised technology.

9.

A key role in harnessing (and utilising) the transformative power of the crowd is played by the camera technologies, from photography and film to television and video. In particular, the transition from symbolic representation to mechanical recording and to image processing, storage and manipulation (in both analogue and numerical formats) has, since the beginning of the twentieth century, produced a new order of information which, being neither true nor false, denies participation, resists transformation and generates instant polarisation of positions. The photographic or photo-based image is not merely an inert trace but an implosion of a 'photographic event.' As with a black hole, metaphorically speaking, nothing can escape from the image. Nothing can therefore be transformed in the process of communication. Instead, communication itself seems to be absorbed by/into the image.

10.

This, however, is not to suggest that these images, moving or still, are in any way immutable. On the contrary, subsequent manipulation with the recorded image is in many respects intrinsic to photo-based media. (Its use dates back to the beginnings of the photographic time and is not only a standard practice in all movie making, in advertising, propaganda, editorial illustration, architectural design and, of course, art, but it is also a necessary condition of the image technology.) The manipulation of the image presents itself as an effect of (technological) reality

which cannot be re-absorbed into the immediate reality of direct social contacts. It seems to be precisely the technology's power to manipulate time and space, to collapse it into the image, that makes claim on individual perceptions, consciousness and memory while it demobilises the collective powers of the crowd.

It abolishes the connections between space, time and experience by seamlessly fusing the present moment with the past in a perpetual appearance and disappearance of images which follows its own chronology of broadcast and publication schedules and which overthrows the order of geography by uniting all locations into one, on the same 'dimensionless' picture plane or screen.

11.

The confusion that this creates is best illustrated by the example of the everyday diet of the news. In an older model in which the dissemination of information still involves human interaction (and the necessity of active participation), such as the purchase of the newspaper from a street vendor, a certain awareness of a chronology of events is maintained: we know that even the 'latest' news is already old news; or that, metaphorically speaking, there is no such a thing as 'today's paper.' With the technologically more advanced media, such as television, which combines 'live' elements with recorded and reconstructed information, it becomes very difficult to maintain a sense of correspondence between space, time and experience.

12.

We are 'bombarded with images,' as the old cliché goes, in a kind of perpetual 'precision bombing' campaigns (a notion which emerged at

the time of the first 'television war,' the American intervention in North Vietnam in the mid sixties). The same technology which assists a 'pin-point accuracy' in disseminating death also creates a deadly isolation of each individual when it is aimed at the crowd.[3]

In the near future, the miniaturisation of

equipment, electronic super highways, interactive television etc., will probably shatter even the last remains of collective public interaction by vastly multiplying image-realities and competing for the 'public domain' from a myriad of individual and corporate centres of influence.

13.

Like in an open-air cinema where, at night, the projected collides with the reflected and 'architecture becomes the paradox of the show,'[4] the contemporary city is a continuously re-organised image-space. Its walls and boundaries are not merely shifting, contracting and expanding with a flow of images – they are, in fact, only perceptible as 'afterimages' (retinal residue) always in the process of disappearing. The street, the agora, the forum, or the piazza, have dissolved in the limitless periphery of global satellite TV transmissions and mail-order shopping. The only space still reserved for 'public gatherings' is the self-defining space of close-circuit television – a space not of transformation but of passive transit. – DUBLIN 1992 - GLASGOW 1995

NOTES

1. Michel Feher and Stanford Kwinter, Foreword, ZONE 1/2, New York, 1987, referring to the article "The Overexposed City" by Paul Virilio in the same publication.

2. Literary expressions such as 'at the centre of the crowd' or 'leading the crowd' really signify outside positions: 'surrounded by,' 'followed by' etc.

3. Indeed, one could almost speak of the effects of these technologies in terms of organised violence, even media torture, in so far as torture and organised violence can be defined as 'an assault on the links and connections between people and the patterns of relationships through which [...] the individual develops further patterns of interaction and communication.' (R. D. Blackwell, THE DISRUPTION AND RECON-STI-TUTION OF FAMILY, NETWORK AND COMMUNITY SYSTEMS FOLLOWING TORTURE, ORGANISED VIOLENCE AND EXILE, Medical Foundation for the Care of Victims of Torture, London, 1989.)

4. For an illuminating discussion of the (con)fusion of urban and cinematic space see Nikos Georgiadis, "Open Air Cinemas: The Imaginary by Night," ARCHITECTURAL DESIGN, vol. 64, no. 11/12, London, 1994.

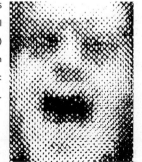

V-Topia

Why does it seem that so many love to hate the spectacle of art keeping pace with technological innovation? Each time an exhibition of digital or electronic art is staged, the gallery reports a record-breaking attendance. One is reminded of Baudelaire's disgust at the infantile curiosity of the crowd when the Daguerreotype hit the streets of Paris; or of the anti-machine scorn of intellectual elites form Ruskin and William Morris to Evelyn Waugh and T. S. Eliot, or the otherwise mild-mannered critic Lewis Mumford for whom technology was 'the walls of a prison'; or of the tired lament of the early techno-convert El Lissitzky: 'enough of... Machine Machine Machine Machine when it comes to modern art.' Or, conversely, is it perhaps that enlightened by Walter Benjamin's sharp rebuke to Aldous Huxley the gallery-going public puts on a show of strength? ('Advances in technology have led to vulgarity,' wrote Huxley, 'the output of trash is greater than it was in the past.' Benjamin: 'This mode of observation is obviously not progressive.')

There is, undeniably, a kind of titillating skepticism to the connoisseur's responses to 'new' technology in art, not least because of all the repeatedly unfulfilled promises of the past – and there is also a new techno-connoisseurship which hides old tribalisms under the fig leaf of 'communication' and 'access.' There is the presumed crisis of content that interactive technology perpetuates which allows the cautiously treading techno-phobe to draw critical parallels between 'state

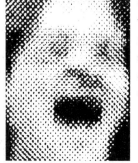

of the art' and the state of art and culture that fails to contain (or justify) its own technological complexity – and there is the pure digital feast for the speaking-in-tongues technophiliac. A concern for art may perhaps help to overcome the prejudices of the skeptic, and a familiarity with the 'techno'

may help to dispel the fear of 'art' so often displayed by the communication enthusiast, but neither explains why the fusion of art and the new electronic media should have any popular appeal.

Nor can the evident ability of digital technology-based art to attract those parts of the audience that other arts cannot reach be fully explained by the proximity of the interactive model to everyday experience. For the emancipatory possibility of this art can only be realised through participation – and it would be hard to claim that in everyday experience there exists any kind of general preference for 'active engagement' over 'passive reception' (or for 'creativity' over 'consumption'). Actually, in competition with the real experience of supermarket shopping, telecommunications or mass entertainment, the promises of interactive art are no better than those of painting or traditional sculpture.

Still, regardless of the conceptual sophistication or aesthetic merit of individual works, the communion of the new media and art does seem to offer a qualified promise of something special. There is a sense of imaginative possibilities being unravelled as the digital images form themselves before our eyes. Unlike photographs which always arrive like strangers and confront our time with the time of their passage, the digital image has no previous identity. It enters time as an open possibility, a transcendent apparition that refers to all its future permutations but has no connection with the past. And this is where we come in, dragging the mouse, clicking the buttons and pressing the keys, or perhaps dressed in the virtual reality guise, to exercise the options which lie ahead of any reality. As the question 'what does this mean?' becomes synonymous with 'how does this work?' or 'what can this do?,' the visions of a future world begin to give way to a vague recollection of a long lost unity of art and magic – the power to trans-

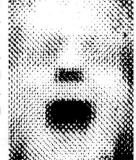

form reality through a symbolic gesture – which decades of technocratic and ideological indoctrination inhibit us from seeing.

It must be the imagined capacity of digital technology to re-invest art with its original magical dimension that raises the expectations of the audience. Strange things do seem to happen in the world

of digital secrets... But they can only be revealed in art when the art names the central contradictory condition: the abdication of control demanded by the machine which alone knows the magical formula. Being in the presence of the self-generating identity of the virtually possible, in the control of its symbolic destiny but not in possession of the powers that command its virtual being, making things happen and not being able to determine their existence, is an experience from the threshold of mutation. And mutation, in this context, means nothing less than a loss of memory – a capitulation of remembering to the concept of memory as an indiscriminately accessible field of data. This is a mutation of the image we, as a culture, as a civilisation, have been striving to form for centuries. An image formed by sifting ideas and observations through the sieve of ethics, arranged according to the ever developing humanistic consensus, an image defined by the never fixed opposites of right and wrong, sacred and profane, noble and base, rather than by the non-negotiable binaries of 1 and 0, on and off, black and white, in which the digital memory draws the future picture of our present past.

– OCTOBER 1994

My Passport and My Photograph

The flows and counterflows of migration crisscross the cultural map of the post-colonial world. A web of influences and interdependencies, diversities and differences is beginning to obliterate the boundaries of Culture laid down with conceited self-indulgence not so long ago. Navigation in and across these currents is more than ever before a matter of negotiating relativities: there are no fixed spatial axioms, only the uncertain points of origins and destinations; no locations, only dislocations. The old bearings of East/West, derived from the geography of conquest, or the more recent North/South co-ordinates, reflecting the reality of multi-nationalist economic orientation, can no longer be relied upon when we are confronted with the unsettling meanderings of cultures in transit. Nor does the techno-political scheme of a three-tier hierarchical world offer more than an abstract image (painted by numbers) when it comes to charting the complexity of cultural dynamics driven by migration. For while the world remains asymmetrically divided along the lines of technological and logistical supremacy, it is often the local cultural divisions that determine the strength and direction of the flow. Migration begins at home, so to say.

Least of all can we make any sense of either the global patterns or the local detail of migration if we perceive the world as a patchwork of national cultures, held together by the boundaries of states. Such cartography defines culture as a system of interlocking frames which separate the individual and collective identities of the 'nationals,' and represents migration as a problem of transference, compatibility and adaptation.

How, then, do we draw a map which would guide us through the terrain stretching between 'here' and 'there' in which we strive to locate 'our' culture so that we may know who we are?

Who are (or where are, or what is) 'we' in these declining years of the Century of the Image? What used to seem so simple has become the most difficult – to imagine ourselves.

Recently, a friend pointed out to me a curious semantic diffraction in my use of the pronouns 'we' and 'they' as though they were interchangeable. The conversation was about Czechoslovakia (a country which no longer exists), where I come from and where he studied, and about Scotland (a country which is not a state), where he was born and where I now live. I was talking about the liberal drinking laws they enjoy in Prague, comparing them unfavourably to those we have in Glasgow; I was musing about the beer we brew in Bohemia and complaining (as Czechs do) about how they, here in Scotland, don't know how to look after it. When in 1979 half of our ice hockey team fled to Toronto and played against us on their side in Vienna, they, my compatriots, didn't know who to cheer for...

We also talked about my passport. It is mine and it is not: it is in my pocket, it has my name on it, yet the note on its last page cautions me that it 'remains the property of Her Majesty's Government.' As it 'may be withdrawn at any time,' it is clearly not mine at all – at least not for as long as I live. When I die, my passport 'should be submitted for cancellation' and then, the last sentence states reassuringly, 'it will be returned on request.' It is a nice thought: born Czech, having arrived in Britain with a one-way travel document which described me as a 'person of undetermined nationality,' and having lived here on a borrowed identity perhaps for the rest of my life, I will depart from this world with a passport truly of my own! The question of my belonging forever resolved.

But until then, there is at least my photograph. It is a picture of me, it was taken by me (strictly speaking – using a railway station photobooth), I paid for it. It exists (for argument's sake) in two copies: I have one in my passport, 'they' have the other in their files. Like identical twins disunited by destiny, the two share an identity of separation. In the eyes of those for whom the photograph was taken ('they,' immigration officers, border guards and such like), the picture is less an image of 'me' than a double of 'their' copy of it. The very proof of my

belonging is in my separation from my photograph: I am what I am identified by: what I belong to but do not possess, what 'they' hold.

This is why they invented passport photographs in the first place: to give me an identity (as a specimen) as they take (or take away) my picture.[1] They noticed that there is always a bond between a photograph and a time and place, that through photographs our lives are tied to locations – if not in the 'real' world, then at least in the nomadic world of images. It is true that our identities based on such 'territorial claims' are no less unambiguous than those that can be constructed in language (where a 'we' is nothing but a range of possibilities legislated by language). After all, photographic images too are mere abstractions, subject to classification, the conditions of use, the laws of optics and the conventions of communication. But it is also true that, somehow, in every photograph we retain possession of what is no longer ours: not just a past but a certain place in history.

Photographs, like maps (and like our shadows), accompany our movements. But unlike maps, which are projections of future journeys, photographs are traces of returns, intersections of past and current passages, 'recurrencies' rather than representations. They keep under a constant tension the fragile links between the residue of lived moments and memory, between where we have been and who we are (what we are always becoming). They differ from maps – and all other images – in another respect too: they never generalise – and, of course, as Barthes famously observed, photographs are without a code and without culture.[2] And without generalisation, there is no equivalence; without equivalence, there can be no exchange, no economy, no transfer of ownership. 'Our' photographs – those that we take or are taken of us, or those that we look at or live with – are ours in the most intimate sense of attachment.

Mobilising the claims we have on 'our' photographs (not 'our' photography!'), holding onto the subjective personal and collective ontologies of those precious fragments of being, could help us to reconstruct a perspective for a different kind of mapping.[3] A mapping which acknowledges that 'departures' and 'arrivals' are not separated by geographic distances but connected by life-spans; that 'home' is not where jour-

neys begin or end but what they pass through; that 'here' and 'there,' 'us' and 'them,' are not opposites but polarities; that 'our' culture is not a given denomination but a name we give to our interaction with others; and perhaps also that 'Tutsi' or 'Tuzla' are not just recent entries in the dictionary of diaspora but part of what we must imagine as 'ourselves.'

As with some photographs, the images we may create through retracing our steps as we move on may be blurred or unfocused but they will help us to build the larger images that we really need: visions of another society, another way of living, the kind of images, mental maps, with which migrations begin – they call them 'hope.'

– OCTOBER 1995

NOTES

1. ... and why 'they,' the Paris police, took the first ones – those of the dead Communards.

2. Not enough space here to argue the point but this is also why they are never 'right' or 'wrong,' neither 'true,' nor 'false.'

3. As the original text was written for a publication accompanying a series of photography exhibitions, this metaphor referred implicitly to the context of public presentation of artwork.

Buster's Bedroom: A Film by Rebecca Horn

There could hardly be a better way of starting a series of screenings of artists' films than with an homage to one of the greatest actors of performance cinema, Buster Keaton, made by one of the great artists of this precarious historical moment, the end of the mechanical era, Rebecca Horn. The two, Keaton and Horn, stand at the opposite ends of a period during which in performance and cinema, the body and the machine have swapped sides, as it were – or during which in art, the moving image has undergone a kind of alchemical transformation from illusion to a new order of reality. Or else, we could see them as being positioned side by side, ahistorically, at a point at which the circular developments of film, as the mechanical counterpart of performance, and performance as the bodily aspect of the cinema, close up on themselves.

Either way, the work of Buster Keaton and that of Rebecca Horn are milestones in that crucially important strand of modern art – or perhaps the only true art of modernity – which keeps alive the tension between the human body and the machine, between the body as a machine and the machine as persona. And it is precisely the concern with the machine-like conditions of the modern body and the life-like operations of the modern machine that makes film so relevant to artists, and that marks, at least to a degree, all the best work of artists-film-makers.

Buster Keaton, born 101 years ago, made his classic films in the 1920s: NAVIGATOR in 1924, the year of André Breton's first Surrealist MANIFESTO; THE GENERAL in 1928, around the time when Marcel Duchamp's Large Glass famously cracked while in transport on the back of a lorry on a bumpy road somewhere in Connecticut. As with early surrealism and its near-obsession with automatic processes and the 'mechanics' of the unconscious, and as with the symbolic 'language engine' and the conceptual 'engineering genius' that drive Duchamp's

work, Keaton's films are not just a product of the machine aesthetics of the times. Rather, they are visionary speculations on the possibilities of creative freedom in the regime of mechanical perfection, explorations of precision for perfectly anarchic and transgressive ends.

The word to describe Keaton's artistic attitude is, perhaps, *animation* – in the literal sense of 'giving soul.' In western art, the soul had gone out of fashion with Romanticism. With modernism, it also had to leave the human body. It was dislocated from its living form. (Why else would anyone come up with the idiotic term 'figurative art,' if it were not for the difficulty in locating the soul within the form of the body?) In fact, the banishment of the soul from the body in modernist art has been so complete that even now we utter the word soul only with utmost trepidation. Yet the soul is not something that would easily go away or curl up and die. If it can no longer reside in the body, some other place must be found for it. And what better place can there be than a machine – something entirely made of imagination – which can provide the surrogate body in which the soul can be reclaimed in a kind of man-machine partnership.

In Rebecca Horn's work since around 1970, the human body and the machine co-exist in close proximity. In her early sculptural pieces and performances, the body acquires, or is equipped with, all kinds of extensions and appendages strapped to the performer's head, fingers, arms or legs, which make the body reach further while simultaneously constraining it. Later on, in the 1980s, she makes strange mechanical automata, powered by motors, which endlessly perform and repeat the same simple actions, seemingly erratic but, in fact, always very precise: two metal hammers suddenly wake up from their dormancy, swing with evident force against each other and stop just a millimetre short of hitting one another, for example, or a very long metal rod suspended from the ceiling swings violently, in a jittery kind of fashion, just a fraction of an inch above an egg placed on the floor.

There is a constant 'ornithological' theme or leitmotif in Horn's work: feathers and plumage, quills and wings. She has made feather masks and body extensions for her performers, motorised feather wheels, several versions of the PEACOCK MACHINE which spreads a set

of long metal 'feelers' fan-like into the space like peacock tail, and machines whose movements are best described by words like 'flapping' or 'pecking.'

There is indeed a whole art form which combines and unites this kind of imagery: a certain kind of formal dance, the flamingo and particularly the tango – inspired by the spontaneity of the courting dances of birds, it requires the bodies of the dancers to move with machine-like precision and co-ordination. For Rebecca Horn, the tango is a key image in her first two feature films, THE DANCING CAVALIER, 1978, and LA FERDINANDA, 1981; for Keaton, the grace of formal dance is always present as an aspiration and latent reference.

In Christian iconography, birds and dancing belong to the symbolism of the soul (think of the dancing angels). In the history of technology, this imagery belongs to the 'dream of flying' – and flying, as we know from the myth of Ikaros/Icarus, has little to do with the practicalities of transportation, but is all about the heroism of transgression, about overcoming the earth-bound condition of our existence in which our imperfectly designed bodies present such severe limitations. As though it was some kind of a perverse joke of the gods to give us the bodies that we have, while also giving us the imagination which can take us so far beyond what our bodies can actually do.

The mechanical era of modernity came up with two different strategies for realising the 'dream of flying.' The first is of course aviation, the flying machine, in which the body can literary rise above the earth (like in an extended leap or jump in a dance). The second strategy is the cinema.

It is not just a coincidence that so many early films include the image of the human body in flight, suspended in the air, or falling through space. And it is also no coincidence that aerial photography was one of the first revolutionary developments following the invention of the cinema. Almost as soon as the image could move, it could also fly.

In Buster Keaton's classic period, in the 1920s, it was still possible to 'dream of flying.' Both aviation and the cinema were still in their pioneering infancy, both still required a considerable investment of

human physical energy, skill and courage to make the body and the imagination fly. The human body was still chasing its soul in the machine. By the 1970s and '80s, the time of supersonic flying, Technicolor cinema and global satellite TV transmission, flying in that ambitious sense of early modernity has become all but impossible. As technology took over from the body, rather than being an extension of it, as it lost its human scale, it also lost that link of animating partnership through which the soul can be reclaimed in the machine. It is now technology, rather than the person, that flies. In this sense, our flying is once again only a dream.

In a short text of 1983 dedicated to Buster Keaton, Rebecca Horn writes:

> His films begin in the daily routine of events, in the streets, backyards, stairways, in scenes of sudden abandonment where railway trains race panic-stricken through the streets, trees are torn up by their roots, houses fly through the air, where the mechanics of human civilisation confront nature, challenge it. In the course of the plot, events escalate to chaotic, threatening signs. He alone through his inventive intelligence can, like a dream-dancer, master the dangers with daredevil precision...

> Gradually he begins to test himself against the energies in short lessons, like bungled acrobatic exercises. ... He develops magical powers which enable him to overcome all obstacles, as unperturbed as a fallen angel. His escape schemes are a ballet in defence of gentle violence. The helpless young man turns into a person who with the help of his mania for inventions is able to tame the elemental forces. Help doesn't come from the animate worlds; rather, he breathes soul into the machines: they become his allies and partners, whom he can trust to aid him in warding off the unleashed energies.[1]

And after mentioning the destructive phase of Keaton's life, his 'falling into silence,' brought about by changes in film production methods and the failure of his marriage, Horn concludes:

In his office at MGM he builds a huge nutcracker where various devilish mechanisms pick up a walnut, toss it through the air, rattle it, shake it to the point of fainting, and finally at the outlet of this monstrous machine crack the walnut. The machine stands for the hierarchical structure of the MGM film company to which he is still bound by contracts and in which he desperately tries to assert himself. He himself has become the little walnut, a parody of his own reality.

He is unable to find the way back to the spiral movements that were able to hurl him into infinity.

He can no longer undo the knots of the strait-jacket. The circle of the earthbound holds him captive, reintegrates him.

Keaton, once elated by the dance of weightlessness, returns for a measured span of time, now cloaked in silence, to the world of the blind.

It must be that metaphorical possibility of flying – what Rebecca Horn calls being 'elated by the dance of weightlessness,' lost somewhere in that span of time between the 1920s silent cinematography and the high technology culture of the last couple of decades – that makes film so attractive a medium to artists. Unlike video, and unlike the new media of digital image-realities, film with its mechanistic foundation still allows us to make analogies with the animating principles of our existence. In a way, every artists' film is a prototype of a machine which contains the promises of freedom for the lost souls of modernity, of flight and escape. But how does this machine do it? Or, as someone wrote of Duchamp's imaginary 'machine,' 'Where does it take us? To answer these questions, the best we can do is to make it run.'[2]

– MARCH 1994

11

NOTES

1. Rebecca Horn, "The Inner Straight-Jacket within the Outer," in REBECCA HORN, ed. Toni Stooss, Kunsthaus Zürich, 1983.

2. This (together with some other borrowings throughout the text) comes from Jean

Suquet whose question about the Large Glass-as-a-machine goes on: '... if it has a meaning, it is in its running. But how are we supposed to make it work since it appears inexorably stopped?' Jean Suquet, "Possible," in THE DEFINITIVELY UNFINISHED MARCEL DUCHAMP, ed. Thierry de Duve, MIT Press, Cambridge, 1991.

Towards the begin ning of WUSA[1], Reinhard
(Paul Newman) throws an aggressive question to the 'Somehow
Good' idealist Martin Rainer (Anthony Perkins): 'What are you try-
ing to prove?' The answer comes with a trademark quiet semi-stutter
but defiantly enough: 'Just to stay alive.' The last line of the script is
Newman's again: 'I am a survivor.'

Between these two rhetorical poles the relative values of 'surviv-
ing' and 'staying alive' are put to test through an obstacle course of a
story that pitches the evidential weight of the apparent against the
circumstantial bias of articulation. The scar on the face of Joanne
Woodward, as Geraldine, matched in a close-up shot to a pimp's knuck-
le ring but repeatedly spoken about as a residue of a past car accident
is only the most prominent token of this precarious contest between
what 'seems to go without saying' and what is said and done. But even
if Geraldine, whose brief attempt to make sense of the choice between
the two existential modes ends tragically with her suicide, is portrayed
as the arbiter, the reference points of the contest are mapped beyond
the actions of the protagonists. They rely on the manipulation of emo-
tional resonance behind appearances and attitudes which makes the
semantic distinction between 'surviving' and 'staying alive' a differ-
ence of considerable degree on the scale of human sentiment.

Mere 'survival' is discredited from the outset by a mercenary voice.
Reinhard introduces himself as a 'communicator.' Having just arrived
in town with nothing he finds a job as an anchorman at WUSA, 'a radio
station with a view,' a supremacist 'voice' of white Louisiana and a cen-
tre of a right-wing political conspiracy. His survival skill is giving voice
to a corporate political deception; his way of staying alive is perpetu-
al drunkenness. In a strange partnership with 'the voice of God' embodied
in a figure of an opportunist evangelist, Reinhard's voice carries the
sermon of survival to the heights of knowing self-delusion – from the

first time we hear Newman speak in the film with the word 'Amen,' through the WUSA sign-off line 'The future of America is in your hands,' to 'We are OK,' raising above the riot at a patriotic convention.

As the contest is taking place on the dark side of liberal social conscience, where drunken babble articulates the mitigating circumstances of indifference, 'somehow good' is as good as good ever gets. For Rainer, a welfare agency researcher engaged in what he discovers to be a bogus social survey, 'just staying alive' is a mode of qualified resistance to symbolic manipulation. It is a soft self-effacing resistance hardened only by what seems like insanity. When he realises that 'his' survey is entrapped in a scenario of racial intimidation and political fraud ('They have some kind of plans to make publicity for themselves by starving people out of town'), Rainer tries to expose the evident but unpunishable criminality by committing a high-profile crime himself. He dies before he can stand at trial and give a public testimony as the machine of manipulation runs out of control and the crowd exposed to it turns into a lynch mob.

In the course of the story, Rainer changes a photographic camera for a gun. Early in the film we see him taking photographs of children at play in a black underclass ghetto. A half way through he is pointing his camera aimlessly at the ceiling as he lies on the bed in his backstreet room. Near the end of the film he takes up his camera for the third time. From high above among the lighting rig of a huge sports arena where a White Power rally had just begun, he uses the camera's telephoto lens to aim a gun. There is a moment of suspense as (the viewer's eye looking through) the camera pans across a line-up of potential targets on a raised platform, from Reinhard to the sheriff and various figures of the local political scene, until it stops focused on the host of the event, the owner of WUSA. Meanwhile in the light-flooded rink below two black and white colour-coded gun-slingers exchange mock-fire in a ritual show of violence 'that made America great.' As the applause rises, Rainer shoots. The bullet hits the chest of the radio station manager seated by his employer's side. Rainer looks through the lens one more time before leaving his place to emerge a few seconds later walking down one of the aisles among the fleeing crowd,

the gun still in his hand, the camera gone.

The half-a-dozen photographs that Rainer takes are presented as 'subjective shots' in the compassionate style of 1970s photojournalism, standing ostensibly for social concern. But the photographic function of the camera soon becomes redundant, as much defeated by the dead weight of the metaphor as a casualty to an overload of cinematographic paradigms: a substitute for the eroticised weapon in the mould of countless film scenes with lonely men in hotel rooms and guns on bedside tables; a moving searchlight surveying the scene; a finger pointing out a suspect at an identity parade and so on. Its presence in the story only seems relevant when photography is posed in a highly symbolic gesture against the mechanistic aspects of the technology of statistics – the supply of cryptic data which Rainer collects in unmarked sealed envelopes from a slum landlord from whom we learn that 'only machines can read them.' The information declares Rainer's handicap in the confrontation of arguments already corrupted by the terms in which they are negotiated. But this is immediately compromised when language is withdrawn and the criteria of the test are left to conjecture. For while the sinister power of the symbol lies partly in the terror of the impersonal secretive operations attributed by the viewer's remote experience to the data-processing technology, compared with the familiar human-sized technology of the photographic camera, its true shock lies in the psychology of the unspoken. When the first yellow envelope is produced from a drawer in the landlord's office and Rainer awkwardly struggles to slip it into his briefcase, the absence of any comment to accompany the exchange implies a complicity in the scheme of corruption. The envelope could be an instrument of bribe. In the subsequent scenes, whenever the envelopes reappear, the accompanying dialogue seems at odds with the action – enough to leave a lingering doubt whether we, the audience, are being told the 'whole story.' In contrast, the mute and unexplained gesture of picture-taking (we never know why Rainer takes the photographs or what happens to them), is entirely different in its impact. It provides a fleeting moment of sympathetic identification between the viewer and the film. It is as if we were being taken into confidence in order to be discreetly reminded that the

premises of the symbolic contest are wholly fictional and, by extension, warned against accepting the unity of the story and the film.

Unlike the content of the envelopes which remains undisclosed (indecipherable to Rainer and unseen by the viewer), the sight of Rainer's photographs is exclusive to the audience. The pictures are presented as minute interruptions visible only from somewhere outside the narrative. They are never shown as photographic prints, nor do we witness the events that Rainer follows through his viewfinder. Instead, introduced by Rainer focusing the lens, each picture pops up on the screen as if from nowhere, a still image registered on the film but unmediated by the action. Even the 'subjects' of the photographs (in the language of photojournalism) who we never observe or notice outside the black and white images seem not to belong to the cast, but seem to enter the narrative as already photographs. As the sound of the camera shutter escorts them into the film, there is a suggestion that the pictures are momentarily taking over from Perkins to play Rainer's part, while the actor is screened off by the cinema screen.

Perhaps because they play only a walk-on part, the photographs behave rather like bad actors, overacting, looking straight into the lens. These 'defects' – the visual equivalent of Anthony Perkins' stumbling diction – try to evoke a consciousness of the 'real' as a way of constructing the ideal of the 'genuine.' And precisely because the action of the still pictures within the film seems deficient, the trick almost succeeds in presenting a case for fiction film as a photographic medium. Or better, in trying to demonstrate its photographic 'weakness,' the trick claims for film an active role on the side of the 'somehow good' where it is to keep alive the reputed simple authenticity of photography against the ravages of fiction. But this claim is knowingly disingenuous. The authenticity attributed to photographs by the conventional photographic wisdom is not in their lack of sophistication but in their inertia, their passive resistance to being 'brought (back) to life' by animation.

The photographs are grouped together in a short rapid sequence with just seconds separating each shot from the next. When with every picture the screen turns for a moment a high-contrast black and white,

it seems like a sudden flaw in the seamless flow of Technicolor perfection caused by an unlikely and inexplicable failure somewhere in the chain of chemical events in the processing lab which bleached the hues out of the colour-sensitive emulsion. The life-like illusionism of the cinema gives way briefly to a sense of actuality of the photographic trace, the absence of colour reveals the presence of a lifeless mechanical imprint. The suspension of motion confirms the impression. Like a film in a moment of crisis, stuck in the gate of the projector and about to burn, the image confesses its attachment to the material world. But in a split-second, movement and colour return to reclaim the passive image for the cinema. The apparently authentic photographic trace is acknowledged in passing but only to be announced as the reality of film. It is put in its place, figuratively as well as technically speaking, brought under the command of the cinema.

Photography is portrayed in the story as a tragic character on the losing side of 'truth.' This is why it must also fall victim to the 'untruth'-fabricating mechanisms within the fiction. But the supposed 'character' of photography is undermined as film becomes self-implicated in the central plot of the story. For the photographs are only look-alikes of photography. They are as fake as the scar on Joanne Woodward's face or the blood on an actor's shirt. The blank shots fired by the two show gun-slingers are in comparison the raw stuff of real life (presuming that live ammunition is rarely used in real-life stage fights). In fact, this seems symbolically hinted at in the construction of the film as the two black and white moments of make-believe 'shooting' are symmetrically positioned at the opposite ends of the story. But if the photographs are explicitly only impostors of photography, their true identity does not even belong to film. It belongs to the script – not the film but the means by which film makes a pact with the cinema (and where it looks for alibi as it is caught stealing the always fake credentials of photography in an artificial light robbery). – 1996

11

NOTES

1. WUSA, Stuart Rosenberg (Paramount, 1970) from a novel HALL OF MIRRORS by Robert Stone.

Shifting Sands

In 1823, sixteen years before the announcement of photography, Daguerre's DIORAMA, the spiritual ancestor of the daguerreotype, was described in THE TIMES as producing an impression 'of a world deserted; of living nature at an end; of the last day past and over ... a stillness which is the stillness of grave,' as if the critic had seen the first photographic image of the desert.

For Jean Baudrillard (in AMERICA, his 1986 travelogue which starts and ends in the California desert), only a real-time representation could convey the experience. 'Snapshots aren't enough... The unfolding of the desert is infinitely close to the timelessness of film.' The geology of desertification, the history of the desert's metaphysics, is 'dragging you down into the whirlpool of time, into the remorseless eternity of slow-motion catastrophe.' But if passing through the desert Baudrillard insists on speed, 'the rite that initiates us into emptiness,' into 'the desert of time,' (and if, recalling the memories of travelling through the same desert, the Mojave, Steve Reich describes the long orchestral opening of the last movement of his DESERT MUSIC as: 'out on the plain, running like hell'), it must be because the 'ecstasy of speed' produces the kind of stroboscopic effect which makes a fast spinning wheel appear stationary or turning slowly in the opposite direction – movement in place, so undetectable that it appears as stillness: the negative image of instantaneity.

This is a very different category of speed than the imperceptible hundredths of seconds that give photography its present-day reputation as a pickpocket. The picture of the desert cannot be 'taken,' discreetly, from below the threshold of perception. Nor can the desert be 'exposed,' in the photographic manner, by strictly measured quantities; nor 'captured' in a single time-stopping fraction of an instant; nor 'framed' (like a 'still,' in the jargon of photography) by suppressing duration. As the immeasurable tectonic time seems to be its only dimen-

sion, and its visual essence, the desert can only appear to the photographic gaze as an impression in constant flight – and even then, only as an afterimage, that effect of the eye's inability to forget fast enough. And time is what the eye sees as the gaze falls through layers of overlapping images and into a vertiginous vastness from which memories cannot be retrieved.

I bought Baudrillard's book some weeks after I had travelled along the freeway that inspired his rear-view mirror observations, from Las Vegas to Los Angeles. On the cover of AMERICA there is a picture (by Richard Misrach) of a family camping defiantly in what looks like a desert parking lot. There are no shadows on the ground and the four people with their pick-up truck and tents seem suspended, superimposed over an empty space rather than standing in it. The stars-and-stripes flag on an aluminium flagpole in the centre of the group gives the small camp the appearance of a strange vehicle, a spacecraft. In fact, the whole picture is just like the famous photograph of Buzz Aldrin trying to make his first steps in the weak gravity of the Moon on July 21, 1969, remarkable, above all, for the total absence of any sense of Cosmos. It sums up exactly the impressions from my journey: travelling parallel to actuality, seeing nothing that I had ever seen and nothing I will ever see again, finding not a thing that could later restore the experience of recollection.

The desert is a place of transit, not a destination, a zone rather than a location. This is why I cannot arrive at a singular image (or why Baudrillard could not settle for an isolated moment of the 'snapshot'). Unlike islands which are supremely photogenic, the desert offers no vantage point for the photographer. Where the image of an island emanates from the hot intensity of its volcanic heart which draws the sight towards the focus of its centre, deserts emerged from the cold of the geological night as vestiges of disappearance; and where an island rises, Narcissus-like, above its reflection in the surrounding waters, the desert is always already concealed in its own image: as if its surface bowed in the intense heat in and out like a warped two-way mirror, convex and concave at the same time, displacing every reflection, turning every reflection into a mirage. Islands live by their shores, are

approached and explored from the outside, circumnavigated and circumscribed. The image of an island (even a desert one) always faces inwards from the edge of distance. But the desert is an 'all around' and distance (the image of time) is all that there is. It cannot be seen from far away, like an island from aboard the ship, it has no outline, no contour, no exterior. Traversing it, the traveller is facing from a perpetually concentric perspective towards the nowhere of the horizon. The only image possible here (in passing) is transcription.

Yet even the desert has a heart. Before Bikini, and long before the Mururoa, there were White Sands and Alamagordo, New Mexico, the hiding site of the first atomic-bomb test, right 'in the middle' of a desert. The desert heart, its dead centre (in both senses of the phrase), was located by vertical penetration. An infernal machine implanted deep in the bedrock inverted geology, turning it inside out. Tearing through from underneath its surface, the technology of instant exteriorisation exposed the desert for the first time in a kind of photographic proximity. The magnitude of the detonation threw millions of years of erosion into fast forward. Time itself was erased. An eternity, a chronology in which History is of no significance, was consumed in a brief flash of brilliant light. The heart of the desert, or a blind spot – the place where on an island lies buried the fantasy of a treasure, forbidden to sight like a nuclear blast under the penalty of blindness – was the site of perversely accelerated excavation. The image born in the upward thrust of the exploding bomb, in the artificial illumination infinitely brighter than the desert sun, is an image of an archaeology, of an enterprise of image-making. Like all archaeology, this confrontation with depth and time beyond the range of the visible is a projection; its violent image is a proposition for the desert of the future. Still, this meta-image is, at best, something like a photograph in reverse, an indication of uncertainties. It succeeds in undoing the past but fails to reinvest it with new secrets.[1]

All the extreme brutality with which the twentieth century blasts its way into the mysteries of emptiness is powerless here. The unstoppable drive of History doesn't shift a single grain of sand. Even the loathing that Evolution itself displays for horizontality, from the first

blade of grass to the rocket launch – nothing in comparison with the fury of the elements which left these devastated expanses lying for dead – will not make the desert obey the order of perspective (or 'pose for the camera,' in a more humanly banal metaphor). How can this space beyond measurable limits be turned into a 'landscape' by the feeble apparatus of photography which knows nothing but fleeting reflections of light and the temporary play of shadows? From what kind of an objective disposition can the seeming impossibility of intervention be confronted? What does it take to see the desert and not to loose sight of it? And what does it take to get close enough?

The only credible view of the desert is the vista from the sky, from the disbelief-defying unnatural high vantage point of aerial photography – from which the eye sees everything and recognises nothing; the perspective of disengagement; altitude rather than attitude.

In the film PATRIOT GAMES (1992, from a pre-Desert Storm novel by Tom Clancy), an ex-CIA analyst played by Harrison Ford is involved in a transcontinental chase after an IRA cell. Having tracked down his adversaries to one of the 'hundred-and-eighty, perhaps more' terrorist training camps in 'North Africa,' he watches the spectacle of their killing by the SAS on a satellite monitor in a screen-filled Pentagon operations room, darkened as if for a cinematic performance. To the sound of a helicopter rotor blades cutting through the air, half a dozen virulent white specks on a dark blue screen attack a small group of rectan- gular lar shapes, the tents, which on impact emit more, somewhat darker, moving spots. Then, in silence, the darker spots freeze and turn into human silhouettes as bodies lie dead scattered on the desert sand. There is nothing between Washington and 'North Africa' but a satellite link – and in our mind's eye, saturated with newspaper images, a soldier crouched against the wall in a Belfast shopping mall, in full camouflage.

Camouflage is a strategy of disappearance, invisibility, visual interruption (from which Paul Virilio derived his AESTHETICS), of non-differentiation and indifference. Outside cities, outside the civil life, camouflage is a porous image. At least since the Vietnam war, it is above all associated with the jungle – and jungle, in turn, with nature at its

purest: form dissolving into process 'in front of our eyes.' But in the desert, process and form have nothing to do with nature. They are abstractions perceptible only against the transient human presence. Just as in the 'urban jungle' camouflage fatigues give form to an attitude (and make the wearer an easy prey to the predator with the camera), so in the desert camouflage is the opposite of a voluntary absorption into a self-transforming image of the environment. It doesn't conceal or disguise. It deceives precisely by making visible. It plays its hide-and-seek tricks somewhere between the phenomenal world and language. In 1991 the US military designers had to create new camouflage patterns for 'the Gulf.' The results were, of course, quite unlike those which share their visual exuberance with the Asian jungle: they were covered in small dark glyphic shapes on a light ground, like a writing whose meaning and origin is long lost. But despite looking like alphabet soup in ancient Arabic, the Desert Storm camouflage designs were doubtless inspired by the appearance of the desert from the air. They look, in a day-time colour scheme, just like the clusters of tiny abstract figures watched by Harrison Ford on the monitor screen and exactly like what Buzz Aldrin may have seen seconds before landing back on the Earth. These are the same patterns that you find on a map, the same random scattering of shapes and marks meaningless without interpretation. As the tactics of camouflage is confusion, the likeness of the desert had to be transcribed into the graphic jargon of an imagination at war with itself – one which dominates in its air-born incomprehensibility, or sky-high incomprehension, all terrestrial existence and imposes its codes from above. Nothing is safe from its obsessive multiplication of simultaneity (from simulation, as Baudrillard would have it), or can escape the cold heat-seeking attention of its technologies, except that which hides in representation. This is what the Iraqi soldiers must have understood when they suspended all the ornamental rules of Islamic art and painted 'bomb craters' on the runways of their deserted desert airports.

The desert camouflage patterns came into being from among the pixels on the digital retina of a spy plane camera 'reading' the surface of the desert. They were first seen, by those who created them, in pho-

tographic images which came (or 'came in') from reconnaissance beyond recognition and which showed that invisibility was the desert's visible guise. Up in the skies, the textures of sand, light and wind became the referents of the invisible. But down below, where it was designed for and destined to be, the camouflage is a screen between the desert and the eye, a filter of ciphers which enhances the image so that the emptiness finally submits to photography. This is what it means to be close to the ground.

The critic of the 1820s' diorama did perhaps see an image of the desert: 'world deserted ... living nature at an end.' But with all the Schopenhauerian pessimism of his times he couldn't have foreseen the reign of total visibility a hundred and seventy years later, where even in the desert there is no escape from iconography; where even the 'stillness of grave' has been invaded by ideology which alone is the photographic condition; where the image, imagination and the unimaginable merge in Babylonian insanity; where men no longer fly on the wings of vision but in machines which are deadly projections of optics; and where they no longer go to confront their beliefs but where they venture to confirm their loss of faith. Whether armed with a submachine gun, a spade, or bent under the weight of cameras and tripods, the contemporary desert explorer always finds the same image: sky above, sand below, and a labyrinth of shifting signs everywhere.

(On holiday with my wife at Easter 1993, we drove across the south-western corner of the Namib desert, diamonds under the wheels, passing warning road signs indicating 'WIND' and 'SAND,' as if the two could be separated. We arrived for the night in a place with the improbable indexical name of Aus (either a bizarre example of German administrators' sense of humour or a demonstration of their toponymic precision): a petrol pump, several houses and corrugated metal shacks, remains of a railway station and Hotel Bahnhoff. On the wall in the hotel bar was a picture faded by thirty years of sunlight: the desert under snow... At last, there was the first photograph of a real desert: temporal in the very human terms of meteorological unpredictability and on the scale of living memory. Quite unbelievable.)

12.

– MARCH 1996

1. The ghastly 'photographic evidence' deposited on the pavements and walls of Hiroshima on the island of Honshu is of a different order: not the trace of the exposure but of extermination, not transition but transgression.

NOTES ON THE TEXTS AND PHOTOGRAPHERS

ON REFLECTION

p. 11

Previously unpublished.

BETWEEN THE LINES

p. 27

A shorter version of this text appeared as a review
in CREATIVE CAMERA, no. 3, 1987.

Edwina Fitzpartick graduated from Brighton Polytechnic in 1984.
Her installation, BETWEEN THE LINES, was shown at the Cambridge
Darkroom in the Spring of 1986, to launch the artist's self-published book
of the same title. In recent years, she has been contributing workshops
and talks to the education programmes at the Whitechapel and
Hayward Galleries in London, and in 1996, she was commissioned by
the Institute of International Visual Arts to undertake a research
project at Phillips Petroleum and Toxides, Cleveland.

BLACK (AND WHITE) MAGIC

p. 32

First draft of a catalogue essay for the exhibition FIGURES, Cambridge
Darkroom, June 1987, presenting the work of Sue Arowsmith, Helen
Chadwick, Sorel Cohen, Harald Falkenhagen, Joe Gantz, Roberta Graham,
Ján Krízik, Jean-Marc Prouveur and David Ward. A performance
programme, organised in collaboration with Projects UK, featured
Mona Hatoum, Andre Stitt and Nick Stewart.

PHOTOGRAPHY NOW

p. 35

Review of an exhibition commemorating 150 years of photography,
curated by Mark Hayworth-Booth, Victoria and Albert Museum,

London, 1989. A severely edited version of the text was
published in CREATIVE CAMERA, no.6, June 1989.

ANGLED MIRRORS
p. 39

Original version of an article published in a special issue of CREATIVE
CAMERA, nos. 8/9, Summer 1989, alongside the work of
Heinz Cibulka, Lynne Cohen, Harald Falkenhagen, Axel Hüte,
Alexander Rodchenko, Josef Sudek, and Nikola Vuco.

LOST (FOR) WORDS
p. 45

Published as a review of an exhibition at Fotohof, Salzburg,
CREATIVE CAMERA, no. 317, August 1992.

Roger Palmer studied at Portsmouth and Chelsea Schools of Art.
He is best known for his landscape-based work combining photogra-
phy and text which has been exhibited widely in Britain and abroad
since the mid-1970s. In 1985 he made the first of many working visits
to South Africa and produced a series of works, PRECIOUS METALS,
exhibited at the Serpentine Gallery, London, and published by
Cambridge Darkroom the following year. A selection of his work from
the next decade was brought together by Oriel Mostyn, Llandudno, in
the exhibition and publication REMARKS ON COLOUR in 1995.

SHADOW-CATCHERS
p. 50

Parts of this unpublished draft were used in the reviews of the
exhibitions of Craigie Horsfield at ICA, London, CREATIVE CAMERA,
no. 313, December 1991, and David Ward at RIBA Gallery,
Cambridge, CREATIVE CAMERA, no. 314, February 1992.

Craigie Horsfield took up photography as a painting student at
St. Martin's School of Art, London, in the late 1960s. Over the
following two decades, Horsfield took hundreds of photographs in
Poland, where he lived for much of the 1970s, and East London, where
he settled on his return to Britain. He began exhibiting this work in

1988 with a solo exhibition at the Cambridge Darkroom followed by shows in London, Cologne, Paris, Toronto, New York and elsewhere, and a series of important international surveys curated by Jean-François Chevrier and James Lingwood. The first monograph of Horsfield's work, presenting a selection of pictures from the past twenty years, accompanied his 1991 exhibition at the Centre for Contemporary Arts in London, organised in collaboration with several major European museums. In 1996, Horsfield was nominated for the Turner Prize for a body of new work created in Spain and shown in Barcelona the previous year.

PORTRAIT OF L I BREZHNEV

p. 54

Previously unpublished.

A MASS OF FIGURES

p. 57

Published as an exhibition pamphlet for JIM HAROLD: MASS OF FIGURES, Cambridge Darkroom, January 1992.

Jim Harold studied sculpture at Reading University but worked, and began exhibiting in the late 1970s, primarily as a photographer. More recently, his installations, such as those at the Cambridge Darkroom in 1992 or Glasgow's Tramway in 1996, and his collaborations with the video artist and photographer Susan Brind, have combined both practices with architectural intervention in the space of the gallery. Harold has also co-edited several issues of the magazine CREATIVE CAMERA and curated two exhibitions at the John Hansard Gallery in Southampton, NATURE AFTER NATURE, 1992, and DESERT, 1996.

THE FREEZE

p. 61

Previously unpublished.

John Stezaker belongs to a generation of British artists who in the late 1960s worked with photography within the framework of analytic conceptual art. In the first half of the 1970s he turned to appropriated or found imagery which has remained the sole source of his subsequent work. Stezaker was involved with the culture magazine ZG (1980-84) and has been influential as a teacher at the St Martin's and currently at the Royal College of Art in London. His photo-based works and collages have been widely exhibited and published. A retrospective account of the strategies deployed in his early work appeared recently in an interview with John Roberts, "The Impossible Document: Photography and Conceptual Art in Britain," 1966-76, CAMERAWORK, London 1997.

VIRTUAL CONFUSION
p. 90

Edited extract from the pamphlet WORDS IN THEIR NATURAL SETTING (Tramline no.1, Tramway, Glasgow, August 1994), published in THE HANDBOOK: CONFERENCE FOR EUROPEAN PHOTOGRAPHERS, The Robert Gordon University, Aberdeen, November 1995.

A SHADOW OF THE CROWD
p. 93

Presented at the conference SCULPTURE IN THE CITY, Athens, October 1995, and first published in COIL, no. 4, February 1997. An earlier version of this paper appeared in CITY AS ART: INTERROGATING THE POLIS, edited by Liam Kelly, International Association of Art Critics, Dublin, 1995.

THE VOICE OF THE PEOPLE
p. 93

Eight monochrome photographs, 60 x 50 cms each. First shown in a survey exhibition of Czech exile photography, CESKOSLOVENSKÁ FOTOGRAFIE V EXILU, curated by Anna Fárová, Mánes, Prague, February 1992.